Daniel Birnbaum Amanda Sharp Jörg Heiser

Doug Aitken

Contents

Selected exhibitions and projects
1980–93

1980
Spends half a year in the Soviet Union

1985–86
Spends extended time in Africa

1985–86
Spends extended time in central and south America

1986–87
Studies, Marymount College, Palos Verdes, California

1987
Works on a kiwi and orange farm in central California

1987–91
Studies, BFA in illustration, Art Center College of
Design, Pasadena, California

Object making and site-specific installations

1988
Spends extended time in the central Pacific

1991
One of the founding photographic artists, with David
Carson, of *Ray Gun* magazine

Moves to New York

First film-related work

'Artworks/Artworkers',
AC Project Room, New York (group)

1992
Films *fury eyes* in Mojave Desert, California

'Multiplicity',
Christopher Middendorf Gallery, Washington, DC
(group)

'The Art Mall, A Social Space',
New Museum of Contemporary Art, New York (group)

'Invitational 92',
Stux Gallery, New York (group)

1993
Films *autumn*, with Chloë Sevigny, in New York

AC Project Room, New York (solo)

'Okay Behavior',
303 Gallery, New York (group)
Cat. *Okay Behavior*, 303 Gallery, New York, texts Gavin
Brown, Gareth Jones

'Outside Possibilities',
Rushmore Estate, Rushmore, New York (group)

Selected articles and interviews
1980–93

Doug Aitken, c. 1972

Doug Aitken, 1973

1992

Bogan, Neill, *Art Papers*, Atlanta, October–November
Kempton, Jim, 'Schrapnel', *WARP Magazine*, United
States, October

1993

Saltz, Jerry, 'Mayday, Mayday, Mayday', *Art in America*,
New York, September
Saltz, Jerry, 'Doug Aitken at the AC Project Room', *Art
in America*, New York, April, 1994

Ac
projectroom

558 broome street
n.y.c., n.y. 10013
ph.212 226 7271
fax.212 334 8214

doug aitken
–dawn–
nov.19 – dec.18 1993
opening friday nov.19, 6-9p

Selected exhibitions and projects
1993–95

'Underlay',
15 Renwick St, New York (group)

'Doug Aitken and Robin Lowe',
AC Project Room, New York (group)

1994
303 Gallery, New York (solo)

Artist's exhibition at senior citizen's retirement centre
Pasco Art Center, Holiday, Florida (solo)

'Beyond Belief',
Lisson Gallery, London (group)

'Audience 0.01',
Flash Art Museum, Trevi, Italy (group)
Cat. *Audience 0.01*, Giancarlo Politi Editore, Trevi, text
Helena Kontova

Vera Vitagioia, Naples (group)

'still',
Espace Montjoie, Paris (group)

'New York, New York',
Ma'nes Space, Prague (group)

'Out West and Back East',
Santa Monica Museum of Art, California (group)

'Not Here Neither There',
Los Angeles Contemporary Exhibitions (group)

1995
Films *monsoon* in Guyana

'La Belle et la Bete',
Musée d'Art Moderne de la Ville de Paris (group)
Cat. *La Belle et la Bete*, Musée d'Art Moderne de la Ville
Paris, text Lynn Gumpert

'The Image and The Object',
Museo Laboratorio di arte Contemporanea, Rome;
Universita Degli Studi di Roma, Rome (group)

Screening, *monsoon*,
Telluride Film Festival

underlay

Doug Aitken
Christine Borland
Dan Devine
Tony Feher
Matthew Higgs
Kim Jones
Kirsten Mosher
Jeanne Silverthorne
Ron Wakkary
Jane & Louise Wilson

curated by Paul Bloodgood
and Gavin Brown

15 Renwick St New York NY 10013
April 2 – May 7, 1993 Wed - Sat by appointment only
Opening reception April 2 7pm – 9pm
Tel 226 7271 or 662 1693

Selected articles and interviews
1993–95

Saltz, Jerry, '10 Artists for the 90s', *Art & Auction*, New
York, May

1994
Author unknown, 'Moonlighting', *New Yorker*, 3.
October
Colman, David, 'Short Takes', *Vogue*, New York,
December
Pokorny, Sydney, 'Doug Aitken: 303 Gallery, New York',
frieze, London, November–December
Weil, Benjamin, 'Ouverture', *Flash Art,* Milan,
May–June

Cork, Richard, 'All Human Life Is Missing', *The Times*,
London, 26 April
Kastner, Jeffrey, 'Beyond Belief', *Flash Art,* Milan,
Summer
Lillington, David, 'Monkey Business – Beyond Belief',
Time Out, London, April
Muir, Gregor, 'Beyond Belief', *World Art*, Melbourne,
June

1995

Di Genova, Arianna, 'Una collezione d'arte', *Il
Manifesto*, Italy, 23 February
Schwartz, Henry, 'The Image and the Object', *Flash Art*,
Milan, March–April

DOUG AITKEN
ROBIN LOWE
JAN 9 — FEB 10
OPENING RECEPTION JAN 9, 6–8
PROJECTS BY
KERRI SCHARLIN ASHLEY KING
BARBARA YOSHIDA'S ONGOING PHOTO-PROJECT 'WOMEN ARTISTS'
A/C PROJECT ROOM
560 BROADWAY 1908 NY NY 10012 TEL 212 226 7271 FAX 212 334 6214

Selected exhibitions and projects
1996–97

1996
Taka Ishii Gallery, Tokyo (solo)

'Campo 6: The Spiral Village',
Galleria Civica D'Arte Moderne e Contemporanea,
Turin, toured to **Bonnefanten Museum**, Maastricht,
The Netherlands (group)
Cat. *Campo 6: The Spiral Village*, Fondazione Sandretto
Re Rebaudengo per l'Arte, Turin, text Francesco
Bonami

'29'-0"/East',
Kunstraum Vienna, Vienna; **Kunsthalle New York**
(group)
Cat. *29'-0"/East*, Kunsthalle New York, text Martin
Kunz

'a/drift: Scenes from a Penetrable Culture',
Bard Center for Curatorial Studies, Annandale-on-
Hudson, New York (group)
Cat. *a/drift: Scenes from a Penetrable Culture*, Bard
Center for Curatorial Studies, Annandale-on-Hudson,
New York, text Joshua Decter

'Intermission',
Basilico Fine Arts, New York (group)

'Art in the Anchorage',
organized by Creative Time, New York,
Brooklyn Bridge Anchorage, New York (group)

'Show and Tell',
Lauren Wittles Gallery, New York (group)

'Doug Aitken, Mariko Mori, Ricardo Zulueta',
Elga Wimmer Gallery, New York (group)

Screening, *bad animal*,
The 34th New York Film Festival, Alice Tully Hall,
Lincoln Center, New York

Screenings, *autumn* and *monsoon*,
The 5th New York Video Festival, Walter Reade Theatre,
Lincoln Center, New York

Screening, *monsoon*,
Boston Film Festival, Massachusetts

Screening, *autumn*,
Champ Libre, Sous la Passerelle, Montreal, Canada

Screenings, *dawn*, *fury eyes*, *inflection* and *monsoon*,
International Festival of New Film and Video, Split,
Croatia

1997
Films *diamond sea* in Namibia

Films *cathouse* in Los Angeles

303 Gallery, New York (solo)

Selected articles and interviews
1996–97

1996

Schmerler, Sarah, 'Art in the Anchorage '96', *Time Out*,
New York, No. 46

Leggat, Graham, 'All of These, None of These: The 1996
New York Video Festival', *Parkett*, No. 48, Zurich, 1997

1997

Talkington, Amy, 'Diamonds in the Desert', *Ray Gun*,
New York, August
Schmerler, Sarah, 'Doug Aitken at 303 Gallery', *Time
Out*, New York, 17–24 April

Selected exhibitions and projects
1997

'I Love New York – Crossover der aktuellen Kunst',
Museum Ludwig, Cologne, Germany (group)
Cat. *I Love New York – Crossover der aktuellen Kunst*,
Museum Ludwig, Cologne, texts Stanley A. Hanks, Rita
Kersting, Christina Lissmann, Jochen Poetter

Artists' website project, *loaded 5x* (with Dean Kupiers),
äda 'web, **Walker Arts Center**, Minneapolis, Minnesota
<http://adaweb.walkerart.org/project/aitken/>

'Speed – *Visions of An Accelerated Age*',
Photographers' Gallery, London; **Whitechapel Art
Gallery**, London (group)
Cat. *Speed – Visions of An Accelerated Age*, The
Photographers' Gallery, London, texts J.G. Ballard,
Peter Wollen, et al.

'Poor Man's Pudding; Rich Man's Crumbs',
AC Project Room, New York (group)

'The 1997 Whitney Biennial',
Whitney Museum of American Art, New York (group)
Cat. *The 1997 Whitney Biennial*, Whitney Museum of
American Art, New York; Abrams Publishers, New York,
texts Louise Neri, Lisa Philips, et al.

'We Gotta Get Out of this Place,
Cubitt Gallery, London (group)

'One Minute Scenario',
Le Printemps de Cahors, Saint-Cloud, France (group)
Cat. *One Minute Scenario*, Le Printemps de Cahors,
Saint-Cloud, France, text Jerome Sans

'Doug Aitken and Peter Gehrke',
Galleri Index, Stockholm (group)

'Camera Oscura',
San Casciano dei Bagni, Italy (group)

'Doug Aitken, Alex Bag, Naotaka Hiro,
Taka Ishii Gallery, Tokyo (group)

'(re)Mediation: The Digital in Contemporary American
Printmaking',
22 International Ljubljana Biennal of Graphic Art,
Cankarjevdom-Cultural and Congress Centre,
Ljubljana; **Modern Gallery**, Ljubljana; **Tivoli Gallery**,
Ljubljana (group)

Film festival, 'Montreal International Festival of
Cinema and New Media',
Montreal, Canada

Film festival, 'film+arc.graz: Third International
Biennale',
Graz, Austria
Cat. *film+arc.graz*, Third International Biennale, Graz,
Austria

Film festival, 'Video Divertimento',
San Casciano Dei Bagni, Italy

Artist's project, 'Adrenalin', *i-d*, London, December

Selected articles and interviews
1997

Gisbourne, Mark, 'I Love New York – Crossover of
Contemporary Art', *Contemporary Visual Arts*, No. 22,
London

McKenna, Kristine, 'It Happens Every Two Years', *Los
Angeles Times*, 9 March
Searle, Adrian, 'Nowhere to Run', *frieze*, No. 34,
London, May

Sandhu, David, 'Exhibition of the Month: We Gotta Get
Out of this Place', *i-d*, London, December

Madestrand, Bo, 'Unpacking the Fashion Pack: Doug
Aitken and Peter Gehrke at Galleri Index, Stockholm',
Material, No. 32, Stockholm, Spring

Artists' website project, **loaded 5x** (with Dean Kupiers)

Selected exhibitions and projects
1997–98

1998
Films *eraser* in Monserrat, West Indies

Films *these restless minds* in Oklahoma, Texas and
South Dakota

Moves from New York

Nearly drowns in the Pacific Ocean, unconscious for
four days

303 Gallery, New York (solo)

Jiri Svestka Gallery, Prague (solo)

Taka Ishii Gallery, Tokyo (solo)
Artist's book, *METALL IC SLEEP*, Tokyo, Taka Ishii
Gallery, Tokyo

METALL IC SLEEP

DOUG AITKEN

Gallery Side Two, Tokyo (solo)

Text, *Sogni/Dreams*, ed. Francesco Bonami and Hans
Ulrich Obrist, Fondazione Sandretto Re Rebaudengo
per l'Arte, Turin

'New Selections from the Permanent Collection',
Walker Art Center, Minneapolis, Minnesota (group)

'portrait–human figure',
Galerie Peter Kilchmann, Zurich (group)

'La Voie Lactée',
organized by the Purple Institute, Paris
Alleged, New York (group)

'L.A. Times',
Palazzo Re Rebaudengo, Guarane, Italy (group)

'New Visions: Video 1998',
Long Beach Museum of Art, California (group)

'Unfinished History',
Walker Art Center, Minneapolis, Minnesota (group)
Cat. *Unfinished History*, Walker Art Center,
Minneapolis, Minnesota, text Francesco Bonami

Selected articles and interviews
1997–98

Newhall, Edith, 'Talent: Glimmer Fields', *New York
Magazine*, 14 April
Cameron, Dan, 'The Year's Best', *Artforum*, New York,
December

1998

l. to r., James Fish, Doug Aitken, 1998

Arning, Bill, 'Doug Aitken: 303 Gallery', *Time Out*, New
York, 7 January
Author unknown, 'Doug Aitken at 303', *Flash Art*,
Milan, January–February, 1999
Cincinelli, Saretto, 'Pitti Immagine Discovery', *Flash
Art*, Milan, June–July, 1999
Jocks, Heinz Norbert, 'Ein Fernblick auf New York',
Kunstforum, Cologne, January–February
Krauss, Nicole, 'Doug Aitken: 303 Gallery', *Art in
America*, New York, March
Saltz, Jerry, 'New Channels', *Village Voice*, New York, 12
January

Akasaka, Hideto, 'Mindscape', *Asahi Camera*, Tokyo,
August
Author unknown, 'Doug Aitken: Taka Ishii Gallery,
Tokyo', *Nikkei Art*, Tokyo, August
Pastami, Shumchi, 'Doug', *Esquire*, Tokyo, September
Woznicki, Krystian, 'California on the Mind's Road
Map', *Japan Time*, Tokyo, 19 July

Author unknown, 'Gallery Side 2', *Bijutsu Techo*, Vol.
51, No. 774, Tokyo, August, 2000

Selected exhibitions and projects
1998–99

Film festival, 'International Film Festival Rotterdam', Rotterdam, The Netherlands

Film festival, 'ret.inevitable: Creative Time at the Brooklyn Anchorage', Brooklyn, New York

Film festival, 'International Film Festival', Geneva, Switzerland

1998–2000
Lives nomadically

1999
Films *into the sun* in Mumbai (formerly Bombay), India

Films *electric earth* at multiple locations

Lecture, Dallas Museum of Art

Lectures, Tate Gallery, London, and The Museum of Modern Art, New York

'Concentrations 33: Doug Aitken, Diamond Sea', **Dallas Museum of Art** (solo)

Victoria Miro Gallery, London (solo)

Doug Lawing Gallery, Houston (solo)

'Pitti Discovery Series', **Pitti Immagine**, Florence (solo)

Lannan Foundation (solo)

'dAPERTutto', 48th Venice Biennale (group)
Cat. *dAPERTutto, La Biennale di Venezia: 48a Esposiozione Internazionale d'Arte*, Marsilio, Venice, texts Douglas Fogle, Harald Szeemann, et al.

Receives, International Prize, Venice Biennale

Selected articles and interviews
1998–99

Blair, Dike, 'Sound and Image, Self and Place (Interviewwith Doug Aitken)', *Purple Prose*, No. 13, Paris, Winter
Bonami, Francesco, 'Doug Aitken: Making Work Without Boundaries', *Flash Art,* Milan, May–June
Fogle, Douglas, 'No Man's Land', *frieze*, No. 39, London, March–April
Shave, Stuart, 'Speed Addict', *i-d*, London, October
Wakefield, Neville, 'Let's Go to the Videotape', *Art & Auction*, London, 19 October

1999

Rees, Christina, 'Well-Cut Gem', *Dallas Observer*, 3–9 June

Herbert, Martin, 'Doug Aitken: Victoria Miro', *Londonart*, London, 22 October

Aspesi, Natalia, 'Festa Grande per Artisti Casalinghi', *La Repubblica*, Milan, 10 June
Author unknown, '48 la Biennale di Venezia', *Bijutsu Techo*, Vol. 51, No. 775, Tokyo
Giorgio, Verzotti, 'La Biennale dello Culture Emergenti', *Tema Celeste*, Milan, September
Hayt, Elizabeth, 'Looking Ahead', *New York Times*, 12 September
Heiser, Jörg; Gellatly, Andrew, 'Just Add Water', *frieze*, No. 48, London, September–October
Kimmelman, Michael, 'The Art of the Moment (And Only For The Moment)', *New York Times*, 11 August
Madoff, Steven Henry, 'All's Fair', *Artforum*, New York, September
Robinson, Walter, 'Hi Mom, I'm in Venice', <http://www.artnet.com>
Ryan, Orla, '48th Venice Biennale', *Circa*, No. 89, Dublin
Vertrocq, Marcia, 'The Venice Biennale: Reformed, Renewed, Redeemed', *Art in America*, New York,

I WANTED TO SEE IF A FILM COULD BE CREATED OUT OF LANDSCAPE WITH NO ACTORS OR ACTRESSES. I WANTED TO SEE IF A LANDSCAPE COULD TELL A STORY. THAT WAS THE EXPERIMENT FOR ME.
— DOUG AITKEN ON *DIAMOND SEA*, IN *RAYGUN*, AUGUST 1997

THE DALLAS MUSEUM OF ART
FRIENDS OF CONTEMPORARY ART
INVITE YOU TO THE OPENING RECEPTION FOR

CONCENTRATIONS 33: DOUG AITKEN, "DIAMOND SEA"
(A VIDEO/SOUND INSTALLATION IN THE NORTHEAST QUADRANT GALLERY)

FRIDAY, MAY 21, 1999
6:00 – 9:30 P.M.

6:30 P.M.
TALK BY DOUG AITKEN IN THE ORIENTATION THEATER

7:30 P.M.

PLEASE RSVP TO COLLEEN TUCKER AT (214) 922-1312 BY FRIDAY, MAY 14.

Purple Prose
13
WINTER 1998
$10 - 40 F
THE ABSTRACT ISSUE
ISBN 2-912664-02-1

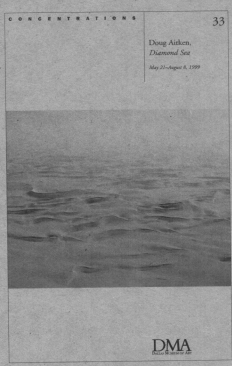

CONCENTRATIONS 33
Doug Aitken, *Diamond Sea*
May 21–August 8, 1999

DMA
DALLAS MUSEUM OF ART

'From Film',
Victoria Miro Gallery, London (group)

'Two Doors – True Value',
Mai 36 Galerie, Zurich (group)

'Video Cult/ures: Multimediale Installationen der 90er
Jahre',
Zentrum fur Kunst und Medientechnologie,
Karlsuhe, Germany (group)
Cat. *Video Cult/ures: Multimediale Installationen der
90er Jahre*, DuMont, Cologne, texts Ursula Frohne,
Kaja Silverman, Yvonne Spielmann, Peter Weibel, et al.

'EXTRAetORDINAIRE',
Le Printemps de Cahors, Saint-Cloud, France (group)
Cat. *EXTRAetORDINAIRE*, Le Printemps de Cahors, Saint-
Cloud, France, text Christine Macel

'Natural Order',
Edmonton Art Gallery, Alberta, Canada (group)

'Clues: An Open Scenario Exhibition',
Monte Video, Amsterdam (group)

Film festival, 'Montreal International Festival of New
Cinema and New Media',
Montreal, Canada

Film festival, '4ième Manifestation Internationale
Vidéo et Art Életronique',
Champ Libre, Montréal, Canada

Film festival, 'Landscape in Motion',
Milan, Italy

Film festival, 'International Film Festival of
Rotterdam',
Rotterdam, The Netherlands

Film festival, 'New Visions: video 1998',
Long Beach Museum of Art, California

2000
Films *i am in you* at multiple locations

Films *blow debris* at multiple locations

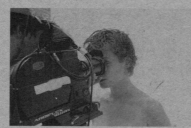

blow debris, in progress, 2000

September
Vogel, Carol, 'At Venice Biennale, Art Is Turning into an
Interactive Sport', *New York Times*, 14 June

Author unknown, 'Video et Photographie Scellent leurs
Noces au Printemps de Cahors', *Le Monde*, Paris, 23
June

de Rooij, Marie, 'Beeldende Kunst', *De Groene
Amsterdammer*, Amsterdam, 2 June

Amadasi, Giovanna, 'Interview with Doug Aitken',
cross, No. 2, Cremona
Anton, Saul, 'Doug Aitken's Moment', *tate*, No. 19,
Winter
Anton, Saul, 'Review', *Artbyte*, New York, June–August
Lubow, Arthur, 'The Curse of the Whitney', *New York
Times Magazine*, 11 April
Lyer, Pico, 'Always Homeward Bound', *Architecture*,
Vol. 88, No. 12, New York, December
Macel, Christine, 'Profile', *Beaux Arts*, Paris, December
Rattray, Fiona, 'Landscape Art', *Blueprint*, No. 159,
London, March
Saltz, Jerry, 'New Channels', *Village Voice*, New York, 12
January

2000

Doug Aitken, 2000

Selected exhibitions and projects
2000

Moves to Los Angeles

Galerie Hauser & Wirth & Presenhuber, Zurich (solo)

'Glass Horizon',
Wiener Secession, Vienna (solo)
Cat. *Doug Aitken*, Wiener Secession, Vienna, text Jörg
Heiser

'Doug Aitken/Matrix 185: Into the Sun',
Berkeley Art Museum, California (solo)

Doug Aitken/MATRIX 185
Into the Sun

July 9 – September 3, 2000

*University of California
Berkeley Art Museum*

Taka Ishii Gallery, Tokyo (solo)

Receives Larry Aldrich Foundation Award,
Ridgefield, Connecticut

'Works from the Angel Collection: Doug Aitken/Electric
Earth',
Museum of Contemporary Art, Nagoya, Japan (group)

'The 2000 Whitney Biennial',
Whitney Museum of American Art, New York (group)
Cat. *The 2000 Whitney Biennial*, Whitney Museum of
American Art, New York, texts Maxwell L. Anderson

INTO THE SUN
DOUG AITKEN

'Hypermental: Rampant Reality 1950–2000 from
Salvador Dali to Jeff Koons',
Kunsthaus, Zurich; **Kunsthalle**, Hamburg (group)
Cat. *Hypermental: Rampant Reality 1950–2000 from
Salvador Dali to Jeff Koons*, Kunsthaus, Zurich;
Kunsthalle, Hamburg, text Bice Curiger

Selected articles and interviews
2000

Dusini, Mathias, 'Netzhaut unter Strom', *Falter Vienna*,
Vienna, 27 October
Mittringer, Markus, 'Hyperaktive Stagnation, Doug
Aitken hat in der Secession', *Der Standard*, Vienna, 21
October
Romano, Gianni, 'Secession', *Flash Art*, Vol. 34, No.
216, Milan, January–February, 2001
Talkington, Amy, 'Ausstellungsempfehlung: Doug
Aitken, Secession, Wien', *Portfolio*, No. 2, Vienna
Vogel, Sabine, *Frankfurter Allgemeine*, Frankfurt, 7
November
Von Grzonka, Patricia, 'Clever & Smart, *Kunst*, Kassel,
October
Withers, Rachel, 'Fall Preview: Guy Wired', *Artforum*,
New York, September

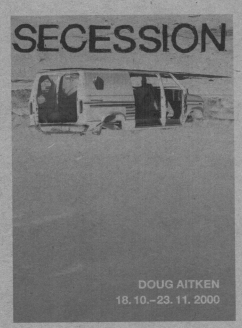

SECESSION

DOUG AITKEN
18. 10.–23. 11. 2000

Author unknown, 'Calendar/Critics Choice', *San
Francisco Bay Guardian*, 5 July
Baker, Kenneth, 'The Fantasy World of Bollywood:
Video Artist Explores Mystique of Movies', *San
Francisco Chronicle*, 12 July
Bonetti, David, 'Bay City Best', *San Francisco Examiner
Magazine*, 9 July
Bonnetti, David, 'BAM Installation Examines Film', *San
Francisco Examiner*, 25 August
Guthmann, Edward, 'India's "Bollywood" Inspires
Video Artist', *San Francisco Chronicle*, 18 July
Helfand, Glen, 'Access Bollywood', *San Francisco Bay
Guardian*, 26 July–1 August
Tsering, Lisa, '"into the sun": Impressions of The
Bollywood Dream Machine', *India West*, United States,
21 July

Author unknown, 'Whitney Museum of American Art',
New Yorker, 8 May
Golonu, Berin, 'Previews', *Artweek*, New York, July–
August
Halle, Howard, '2000 and None: The Whitney Blows the
Franchise', *Time Out*, New York, 6–13 April
Rubinstein, Raphael, 'Regional Hopes & Recycled
Tropes', *Art in America*, New York, July
Wei, Lily, '2000 Biennial Exhibition', *ARTnews*, No. 5,
New York, May

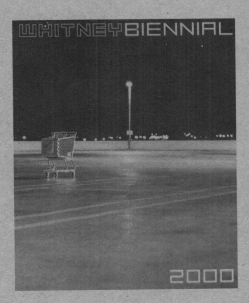

WHITNEY BIENNIAL

2000

Selected exhibitions and projects
2000

'Biennale of Sydney 2000',
Museum of Contemporary Art, Sydney (group)
Cat. *Biennale of Sydney 2000*, Biennale of Sydney, texts
Fumio Nanjo, Louise Neri, Hetti Perkins, Sir Nicholas
Serota, Robert Storr, Harald Szeemann, Nick Waterlow,
et al.

'Speed of Vision',
Aldrich Museum of Contemporary Art, Ridgefield,
Connecticut, toured to **Pittsburgh Center for the Art**,
Pennsylvania (group)
Cat. *Speed of Vision*, Aldrich Museum of Contemporary
Art, Ridgefield, Connecticut, text Matthew Yokobosky

'Flight Patterns',
Museum of Contemporary Art, Los Angeles (group)
Cat. *Flight Patterns*, Museum of Contemporary Art, Los
Angeles, texts Cornelia H. Butler, Lee Weng Choy,
Francis Pound

'Let's Entertain: Life's Guilty Pleasures',
Walker Art Center, Minneapolis, Minnesota; **Centre
Georges Pompidou**, Paris; **Portland Art Museum**,
Oregon; **Kunstmuseum**, Wolfsburg, Germany (group)
Cat. *Let's Entertain: Life's Guilty Pleasures*, Walker Art
Center, Minneapolis, text Philippe Vergne

'Raw',
Victoria Miro Gallery, London (group)

'Future Identities: Reflections from a Collection',
Fondazione Sandretto Re Rebaudengo per l'Arte,
Turin (group)

'Collection',
Arco 2000, Madrid, Spain (group)

Artists' book, *I Am A Bullet: Scenes from an Accelarating
Culture*, Crown, New York, text Dean Kuipers

Artist's book, *diamond sea*, Book works, London

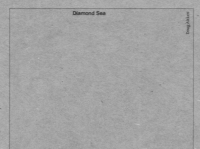

Diamond Sea

Artist's project, 'Turbulence; Blackout; Movement;
Breath In; Weak Link; Mirror', *Blind Spot*, No. 16, New
York

'Anti-Memory: Contemporary Photography II',
Yokohama Museum of Art, Japan (group)
Cat. *Anti-Memory: Contemporary Photography II*,
Yokohama Museum of Art, Japan, texts Amano Taro,
Kuraishi Shino, et al.

Selected articles and interviews
2000

Author unknown, 'No One Needs to Say Sorry', *Sydney
Morning Herald*, 26 May
Author unknown, 'Visual Arts: A Fresh Perspective',
Sydney Scope Magazine, 6 June
Green, Charles, 'The Biennale of Sydney 2000',
Artforum, New York, September
McKenna, Kristine, 'Biennial Man', *LA Weekly*, 17–23
March
Smee, Sebastian, 'Video Drills the Rodeo Star', *Sydney
Morning Herald*, 8 July

Bonetti, David, 'Dark Views of Battered Landscape in
LA Show', *San Francisco Examiner*, 16 November
Feinstein, Roni, 'Museum of Contemporary Art', *Art in
America*, New York
Gerstler, Amy, 'The Video Nomad Comes Home', *Los
Angeles Magazine: The Art Issue*, November
Muchnic, Suzanne, 'She's Trying to Reorient LA's
Compass', *Art and Architecture*, Los Angeles, December
Myers, Holly, 'Horizons, Art, Photography (Mostly) at
MOCA and the Getty', *LA Weekly*, Los Angeles
Pagel, David, 'Flight Patterns Ventures Far', *Calendar
Arts and Entertainment*, Los Angeles, 23 November
Willis, Holly, 'Signal To Noise, Doug Aitken's Blow
Debris', *LA Weekly*, Los Angeles, 8–14 December

Edgerton Martin, Frank, 'That's Entertainment, Let's
Entertain Life's Guilty Pleasures, Portland Art
Museum', *Architecture*, New York, August
Grabner, Michelle, 'Let's Entertain: Walker Arts
Center', *frieze*, No. 54, London, September–October

Adams, Mark, 'Accelerating Art: Aitken, "I Am a
Bullet"', *Rolling Stone*, New York, 14 September
Dery, Mark, 'Killing Time', *Artbyte*, No. 2, New York,
July–August

Kalmar, Stefan, 'Access/Excess', *The Face*, London

Selected exhibitions and projects
2000–01

Film festival, 'Crossing Boundaries',
Danish Film Institute, Copenhagen

Film festival, 'Regarding Beauty in Performance and
Media Arts',
Haus der Kunst, Munich, Germany

Film festival, 'Oberhausen Film Festival',
Germany

2001
'Doug Aitken: Metallic Sleep',
Kunstmuseum, Wolfsburg; **Kunst-Werke Berlin** (solo)
Artist's book, *Notes for New Religions, Notes for No
Religions*, Kunstmuseum Wolfsburg; Cantz, Ostfildern-
ruit, texts Francesco Bonami, Jörg Heiser, Veit Görner,
Gijs van Tuyl

Selected articles and interviews
2000–01

Anton, Saul, 'A Thousand Words: Doug Aitken Talks
about electric earth', *Artforum*, New York, May
Anton, Saul, 'Doug Aitken: New York', *October*,
Cambridge, Massachusetts
Author Unknown, 'Very New Art', *Bijutsu Techo*, No.
782, Tokyo, January
Author unknown, 'Super-flat landscape', *Bijutsu Techo*,
Japan, September
Birnbaum, Daniel, 'Best of 2000', *Artforum*, New York,
December
Bonami, Francesco, 'Liquid Time', *Parkett*, No. 57,
Zurich
Curiger, Bice, 'Doug Aitken', *FRESH CREAM:
Contemporary Art in Culture*, Phaidon Press, London
Paini, Dominique, 'Le Retour du Flâneur', *Artpress*, No.
255, Paris, March
Roberts, James, 'Omega Man', *Parkett*, No. 57, Zurich
Rush, Michael, 'New Media Rampant', *Art in America*,
New York, July
Van Assche, Christina, 'The "Stalker" of the Fin de
Siécle', *Parkett*, No. 57, Zurich

2001
Buhr, Elke, 'Der perfekte Moment', *Frankfurter
Rundschau*, Frankfurt, 21 February
Busing, Nicole; Klaas, Heiko, 'Schwarzer ist schlaflos
in Los Angeles', *Stader Tageblatt*, Germany, 9 March
Busing, Nicole; Klaas, Heiko, 'Zuckungen in der
Endlossschleife', *Saarbrucker Zeitung*, Germany, 9
March
Ebeling, Knut, 'Parabeln der Unbehaustbeit', *Berliner
Zeitung*, Berlin, 6 March
Franke, Anselm, 'Doug Aitken: Videos als
raumfullendes Gebilde', *Wolfsburger Allgemeine
Zeitung*, Wolfsburg, 16 February
Fricke, Harald, 'Leben unter dem Stroboskop', *Die
Tageszeitung*, Germany, 20 February
Hilgenstock, Andrea, 'Der Poet unter den
Videokunstlern', *Die Rheinpfalz Ludwigschafen
Rundschau*, Germany, 26 February
Hilgenstock, Andrea, 'Gigi in der Geisterstadt', *Berliner
Morgenpost*, Berlin, 20 February
Jothady, Manisha, 'Reisen in den Inner Space', *Frame*,
Vol. 5, Germany, January–February
Kuhn, Nicola, 'Der Rap der Grobstadt', *Potsdamer
Neueste Nachrichten*, Germany, 19 February
Kuhn, Nicola, 'Wusten der Grobstadt', *Der Tagesspiegel*,
Germany, 20 February
Nehring, Lydia, 'Elektrische Liebeserklarung?!',
Berliner Morgenpost, Berlin, 15 February
Poschardt, Ulf, 'Surfen statt Zappen', *Welt Am Sonntag*,
Germany, 11 February
Spinelli, Claudia, 'Mediale Entgrenzung: Der
Videokunstler Doug Aitken in Wolfsburg', *Neue Zurcher
Zeitung*, No. 96, Zurich, 26 April
Stoeber, Michael, 'Die Unsicherheit aller Verhaltnisse',
Hannoversche Allgemeine Zeitung, Hanover, 5 March

Selected exhibitions and projects
2001

Artist's project, *Architecture*, New York, February

Serpentine Gallery, London (solo)

Jumex Collection, Mexico City (group)

Selected articles and interviews
2001

Surborg, Jorn, 'Uberraschende Ansichten urbaner Landschaften' *Wolfsburger Kurier*, Wolfsburg, 18 February
Vogel, Sabine, 'Die Welt im Zwichenraum, Zu Doug Aitkens Videoinstallationen' *Kunst-Bulletin*, Kriens, April
Wahjudi, Claudia, 'Frau ohne Eigenschaften', *Zitty*, No. 6, Berlin, 8–21 March
Walder, Gabriela, 'Der Grobstadtnomade von Los Angeles', *Die Welt*, Germany, 8 March
Wulffen, Thomas, 'Amor vacui', *Frankfurter Allgemeine Zeitung*, Germany, 26 February

Fuchs, Christian and Petra Erdamann, 'How to Disappear Completely: Doug Aitken', *Ahead*, United States, January
Pardo, Patrick, 'The Politics of Landscape', *NYArts*, Vol. 6, No. 2, New York, February

Adams, Mark, 'Accelerating Art: Aitken, "I Am a Bullet"', *Rolling Stone*, New York, 14 September, 2000

Aitken, Doug, *METALL IC SLEEP*, Tokyo, Taka Ishii Gallery, Tokyo, 1998

Aitken, Doug, et al., *Sogni/ Dreams*, ed. Francesco Bonami and Hans Ulrich Obrist, Fondazione Sandretto Re Rebaudengo per l'Arte, Turin, 1998

Aitken, Doug, 'Random space', *Big*, 1999

Aitken, Doug, *I Am A Bullet: Scenes from an Accelarating Culture*, Crown, New York, 2000

Aitken, Doug, *diamond sea*, Book works, London, 2000

Aitken, Doug, 'Turbulence; Blackout; Movement; Breath In; Weak Link; Mirror', *Blind Spot*, No. 16, New York, 2000

Aitken, Doug, *Notes for New Religions, Notes for No Religions*, Kunstmuseum Wolfsburg; Cantz, Ostfildern-ruit, 2001

Aitken, Doug, artist's project, *Architecture*, New York, February, 2001

Akasaka, Hideto, 'Mindscape', *Asahi Camera*, Tokyo, August, 1998

Amadasi, Giovanna, 'Interview with Doug Aitken', *cross*, No. 2, Cremona, 1999

Anderson, Maxwell L., *The 2000 Whitney Biennial*, Whitney Museum of American Art, New York, 2000

Anton, Saúl, 'Review', *Artbyte*, New York, June–August, 1999

Anton, Saul, 'Doug Aitken's Moment', *tate*, No. 19, Winter, 1999

Anton, Saul, 'A Thousand Words: Doug Aitken Talks about electric earth', *Artforum*, New York, May, 2000

Anton, Saul, 'Doug Aitken: New York', *October*, Cambridge, Massachusetts, 2000

Arning, Bill, 'Doug Aitken: 303 Gallery', *Time Out*, New York, 7 January, 1998

Aspesi, Natalia, 'Festa Grande per Artisti Casalinghi', *La Repubblica*, Milan, 10 June, 1999

Author unknown, 'Moonlighting', *New Yorker*, 3 October, 1994

Author unknown, 'Doug Aitken: Taka Ishii Gallery, Tokyo', *Nikkei Art*, Tokyo, August, 1998

Author unknown, '48 la Biennale di Venezia', *Bijutsu Techo*, Vol. 51, No. 775, Tokyo, 1999

Author unknown, 'Doug Aitken at 303', *Flash Art*, Milan, January–February, 1999

Author unknown, 'Video et Photographie Scellent leurs Noces au Printemps de Cahors', *Le Monde*, Paris, 23 June, 1999

Author unknown, 'Calendar/ Critics Choice', *San Francisco Bay Guardian*, 5 July, 2000

Author unknown, 'Very New Art', *Bijutsu Techo*, No. 782, Tokyo, January, 2000

Author unknown, 'Gallery Side 2', *Bijutsu Techo*, Vol. 51, No. 774, Tokyo, August, 2000

Author unknown, 'No One Needs to Say Sorry', *Sydney-Morning Herald*, 26 May, 2000

Author unknown, 'Visual Arts: A Fresh Perspective', *Sydney Scope Magazine*, 6 June, 2000

Author unknown, 'Whitney Museum of American Art', *New Yorker*, 8 May, 2000

Author unknown, 'Super-flat landscape', *Bijutsu Techo*, Japan, September, 2000

Baker, Kenneth, 'The Fantasy World of Bollywood: Video Artist Explores Mystique of Movies', *San Francisco Chronicle*, 12 July, 2000

Ballard, J.G., et al., *Speed – Visions of An Accelerated Age*, The Photographers' Gallery, London, 1997

Birnbaum, Daniel, 'Best of 2000', *Artforum*, New York, December, 2000

Blair, Dike, 'Interview/ Sound and Image, Self and Place', *Purple Prose*, No. 13, Paris, Winter, 1998

Bogan, Neill, *Art Papers*, Atlanta, October–November, 1992

Bonami, Francesco, *Campo 6: The Spiral Village*, Fondazione Sandretto Re Rebaudengo per l'Arte, Turin, 1996

Bonami, Francesco, *Unfinished History*, Walker Art Center, Minneapolis, Minnesota, 1998

Bonami, Francesco, 'Doug Aitken: Making Work without Boundaries', *Flash Art*, Milan, May–June, 1998

Bonami, Francesco, 'Liquid Time', *Parkett*, No. 57, Zurich, 2000

Bonami, Francesco, *Notes for New Religions, Notes for No Religions*, Kunstmuseum Wolfsburg; Cantz, Ostfildern-ruit, 2001

Bonetti, David, 'Bay City Best', *San Francisco Examiner Magazine*, 9 July, 2000

Bonnetti, David, 'BAM Installation Examines Film', *San Francisco Examiner*, 25 August, 2000

Bonetti, David, 'Dark Views of Battered Landscape in LA Show', *San Francisco Examiner*, 16 November, 2000

Brown, Gavin, *Okay Behavior*, 303 Gallery, New York, 1993

Buhr, Elke, 'Der perfekte Moment', *Frankfurter Rundschau*, 21 February, 2001

Busing, Nicole; Klaas, Heiko, 'Schwarzer ist schlaflos in Los Angeles', *Stader Tageblatt*, Germany, 9 March, 2001

Busing, Nicole; Klaas, Heiko, 'Zuckungen in der Endlossschleife', *Saarbrucker Zeitung*, Germany, 9 March, 2001

Butler, Cornelia H., *Flight Patterns*, Museum of Contemporary Art, Los Angeles, 2000

Cameron, Dan, 'The Year's Best', *Artforum*, New York, December, 1997

Choy, Lee Weng, *Flight Patterns*, Museum of Contemporary Art, Los Angeles, 2000

Cincinelli, Saretto, 'Pitti Immagine Discovery', *Flash Art*, Milan, June–July, 1999

Colman, David, 'Short Takes', *Vogue*, New York, December

Cork, Richard, 'All Human Life Is Missing', *The Times*, London, 26 April, 1994

Curiger, Bice, *Hypermental: Rampant Reality 1950–2000 from Salvador Dali to Jeff Koons*, Kunsthaus, Zurich; Kunsthalle, Hamburg, 2000

Curiger, Bice, 'Doug Aitken', *FRESH CREAM: Contemporary Art in Culture*, Phaidon Press, London, 2000

Decter, Joshua, *a/drift: Scenes from a Penetrable Culture*, Bard Center for Curatorial Studies, Annandale-on-Hudson, New York, 1996

de Rooij, Marie, 'Beeldende Kunst', *De Groene Amsterdammer*, Amsterdam, 2 June, 1999

Dery, Mark, 'Killing Time', *Artbyte*, No. 2, New York, July–August, 2000

Di Genova, Arianna, 'Una collezione d'arte', *Il Manifesto*, Italy, 23 February, 1995

Dusini, Mathias, 'Netzhaut unter Strom', *Falter Vienna*, Vienna, 27 October, 2000

Ebeling, Knut, 'Parabeln der Unbehaustbeit', *Berliner Zeitung*, Berlin, 6 March, 2001

Edgerton Martin, Frank, 'That's Entertainment, Let's Entertain Life's Guilty Pleasures, Portland Art Museum', *Architecture*, New York, August, 2000

Feinstein, Roni, 'Museum of Contemporary Art', *Art in America*, New York, 2000

Fogle, Douglas, 'No Man's Land', *frieze*, No. 39, London, March–April, 1998

Fogle, Douglas, *dAPERTutto, La Biennale di Venezia: 48a Esposiozione Internazionale d'Arte*, Marsilio, Venice, 1999

Franke, Anselm, 'Doug Aitken: Videos als raumfullendes Gebilde', *Wolfsburger Allgemeine Zeitung*, Wolfsburg, 16 February, 2001

Fricke, Harald, 'Leben unter dem Stroboskop', *Die Tageszeitung*, Germany, 20 February, 2001

Frohne, Ursula, *Video Cult/ures: Multimediale Installationen der 90er Jahre*, DuMont, Cologne, 1999

Fuchs, Christian; Erdamann, Petra, 'How to Disappear Completely: Doug Aitken', *Ahead*, January, 2001

Gerstler, Amy, 'The Video Nomad Comes Home', *Los Angeles Magazine: The Art Issue*, November, 2000

Giorgio, Verzotti, 'La Biennale dello Culture Emergenti', *Tema Celeste*, Milan, September, 1999

Gisbourne, Mark, 'I Love New York – Crossover of Contemporary Art', *Contemporary Visual Arts*, No. 22, London, 1997

Golonu, Berin, 'Previews', *Artweek*, New York, July–August, 2000

Grabner, Michelle, 'Let's Entertain: Walker Arts Center', *frieze*, No. 54, London, September–October, 2000

Green, Charles, 'The Biennale of Sydney 2000', *Artforum*, New York, September, 2000

Gumpert, Lynn, *La Belle et la Bete*, Musée d'Art Moderne de la Ville Paris, 1995

Guthmann, Edward, 'India's "Bollywood" Inspires Video Artist', *San Francisco Chronicle*, 18 July, 2000

Görner, Veit, *Notes for New Religions, Notes for No Religions*, Kunstmuseum Wolfsburg; Cantz, Ostfildern-ruit, 2001

Halle, Howard, '2000 and None: The Whitney Blows the Franchise', *Time Out*, New York, 6–13 April, 2000

Hayt, Elizabeth, 'Looking Ahead', *New York Times*, 12 September, 1999

Heiser, Jörg; Gellatly, Andrew, 'Just Add Water', *frieze*, London, No. 48, September–October, 1999

Heiser, Jörg, *Doug Aitken*, Wiener Secession, Vienna, 2000

Heiser, Jörg, *Notes for New Religions, Notes for No Religions*, Kunstmuseum Wolfsburg; Cantz, Ostfildern-ruit, 2001

Helfand, Glen, 'Access Bollywood', *San Francisco Bay Guardian*, 26 July–1 August, 2000

Herbert, Martin, 'Doug Aitken: Victoria Miro', *Londonart*, London, 22 October, 1999

Hilgenstock, Andrea, 'Gigi in der Geisterstadt', *Berliner Morgenpost*, 20 February, 2001

Hilgenstock, Andrea, 'Der Poet unter den Videokunstlern', *Die Rheinpfalz Ludwigschafen Rundschau*, 26 February, 2001

Jocks, Heinz Norbert, 'Ein Fernblick auf New York', *Kunstforum*, Cologne, January–February, 1998

Jones, Gareth, *Okay Behavior*, 303 Gallery, New York, 1993

Jothady, Manisha, 'Reisen in den Inner Space', *Frame*, Vol. 5, January–February, 2001

Kalmar, Stefan, 'Access/Excess', *The Face*, London, 2000

Kastner, Jeffrey, 'Beyond Belief', *Flash Art*, Milan, Summer, 1994

Kempton, Jim, 'Schrapnel', *WARP Magazine*, United States, October, 1992

Kimmelman, Michael, 'The Art of the Moment (And Only For The Moment)', *New York Times*, 11 August, 1999

Kontova, Helena, *Audience 0.01*, Giancarlo Politi Editore, Trevi, 1994

Krauss, Nicole, 'Doug Aitken: 303 Gallery', *Art in America*, New York, March, 1998

Kuhn, Nicola, 'Der Rap der Grobstadt', *Potsdamer Neueste Nachrichten*, 19 February, 2001

Kuhn, Nicola, 'Wusten der Grobstadt', *Der Tagesspiegel*, 20 February, 2001

Kuipers, Dean, *I Am A Bullet: Scenes from an Accelarating Culture*, Crown, New York, 2000

Kunz, Martin, *29'-0"/East*, Kunsthalle New York, 1996

Leggat, Graham, 'All of These, None of These: The 1996 New York Video Festival', *Parkett*, No. 48, Zurich, 1997

Lillington, David, 'Monkey Business – Beyond Belief', *Time Out*, London, April, 1994

Lubow, Arthur, 'The Curse of the Whitney', *New York Times Magazine*, 11 April, 1999

Lyer, Pico, 'Always Homeward Bound', *Architecture*, Vol. 88, No. 12, New York, December, 1999

Macel, Christine, *EXTRAetORDINAIRE*, Le Printemps de Cahors, Saint-Cloud, France, 1999

Macel, Christine, 'Profile', *Beaux Arts*, Paris, December, 1999

Madestrand, Bo, 'Unpacking the Fashion Pack: Doug Aitken and Peter Gehrke at Galleri Index, Stockholm', *Material*, No. 32, Stockholm, Spring, 1997

Madoff, Steven Henry, 'All's Fair', *Artforum*, New York, September, 1999

McKenna, Kristine, 'It Happens Every Two Years', *Los Angeles Times*, 9 March, 1997

McKenna, Kristine, 'Biennial Man', *LA Weekly*, 17–23 March, 2000

Mittringer, Markus, 'Hyperaktive Stagnation, Doug Aitken hat in der Secession', *Der Standard*, Vienna, 21 October, 2000

Muchnic, Suzanne, 'She's Trying to Reorient LA's Compass', *Art and Architecture*, Los Angeles, December, 2000

Muir, Gregor, 'Beyond Belief', *World Art*, Melbourne, June, 1994

Myers, Holly, 'Horizons, Art, Photography (mostly) at MOCA and the Getty', *LA Weekly*, 2000

Nehring, Lydia, 'Elektrische Liebeserklarung?!', *Berliner Morgenpost*, Berlin, 15 February, 2001

Neri, Louise, *The 1997 Whitney Biennial*, Whitney Museum of American Art, New York; Abrams Publishers, New York, 1997

Newhall, Edith, 'Talent: Glimmer Fields', *New York Magazine*, 14 April, 1997

Pagel, David, 'Flight Patterns' Ventures Far', *Calendar Arts and Entertainment*, Los Angeles, 23 November, 2000

Paini, Dominique, 'Le Retour du Flâneur', *Artpress*, No. 255, Paris, March, 2000

Pardo, Patrick, 'The Politics of Landscape', *NYArts*, Vol. 6, No. 2, New York, February, 2001

Pastami, Shumchi, 'Doug', *Esquire*, Tokyo, September, 1998

Philips, Lisa, *The 1997 Whitney Biennial*, Whitney Museum of American Art, New York; Abrams Publishers, New York, 1997

Pokorny, Sydney, 'Doug Aitken: 303 Gallery, New York', *frieze*, London, November–December, 1994

Poschardt, Ulf, 'Surfen statt Zappen', *Welt Am Sonntag*, 11 February, 2001

Pound, Francis, *Flight Patterns*, Museum of Contemporary Art, Los Angeles, 2000

Rattray, Fiona, 'Landscape Art', *Blueprint*, No. 159, London, March, 1999

Rees, Christina, 'Well-Cut Gem', *Dallas Observer*, 3–9 June, 1999

Roberts, James, 'Omega Man', *Parkett*, No. 57, Zurich, 2000

Robinson, Walter, 'Hi Mom, I'm in Venice', <http://www.artnet.com>, 1999

Romano, Gianni, 'Secession', *Flash Art*, Vol. 34, No. 216, Milan, January–February, 2001

Rubinstein, Raphael, 'Regional Hopes & Recycled Tropes', *Art in America*, New York, July, 2000

Rush, Michael, 'New Media Rampant', *Art in America*, New York, July, 2000

Ryan, Orla, '48th Venice Biennale', *Circa*, No. 89, Dublin, 1999

Saltz, Jerry, '10 Artists for the 90s', *Art & Auction*, New York, May, 1993

Saltz, Jerry 'Mayday, Mayday, Mayday', *Art in America*, New York, September, 1993

Saltz, Jerry, 'Doug Aitken at the AC Project Room', *Art in America*, New York, April, 1994

Saltz, Jerry, 'New Channels', *Village Voice*, 12 January, 1998

Saltz, Jerry, 'New Channels', *Village Voice*, New York, 12 January, 1999

Sandhu, David, 'Exhibition of the Month: We Gotta Get Out of this Place', *i-d*, London, December, 1997

Sans, Jerome, *One Minute Scenario*, Le Printemps de Cahors, Saint-Cloud, France, 1997

Schmerler, Sarah, 'Art in the Anchorage '96', *Time Out*, New York, No. 46, 1996

Schmerler, Sarah, 'Doug Aitken at 303 Gallery', *Time Out*, New York, 17–24 April, 1997

Schwartz, Henry, 'The Image and The Object', *Flash Art*, Milan, March–April, 1995

Searle, Adrian, 'Nowhere to Run', *frieze*, No. 34, London, May, 1997

Shave, Stuart, 'Speed Addict', *i-d*, London, October, 1998

Shino, Kuraishi, *Anti-Memory: Contemporary Photography II*, Yokohama Museum of Art, Japan, 2000

Silverman, Kaja, *Video Cult/ures: Multimediale Installationen der 90er Jahre*, DuMont, Cologne, 1999

Smee, Sebastian, 'Video Drills the Rodeo Star', *Sydney Morning Herald*, 8 July, 2000

Spielmann, Yvonne, *Video Cult/ures: Multimediale Installationen der 90er Jahre*, DuMont, Cologne, 1999

Spinelli, Claudia, 'Mediale Entgrenzung: Der Videokunstler Doug Aitken in Wolfsburg', *Neue Zurcher Zeitung*, No. 96, Zurich, 26 April, 2001

Stoeber, Michael, 'Die Unsicherheit aller Verhaltnisse', *Hannoversche Allgemeine Zeitung*, Hanover, 5 March, 2001

Surborg, Jorn, 'Uberraschende Ansichten urbaner Landschaften' *Wolfsburger Kurier*, Wolfsburg, 18 February, 2001

Szeemann, Harald, *dAPERTutto, La Biennale di Venezia: 48a Esposiozione Internazionale d'Arte*, Marsilio, Venice, 1999

Talkington, Amy, 'Diamonds in the Desert', *Ray Gun*, New York, August, 1997

Talkington, Amy, 'Ausstellungsempfehlung: Doug Aitken, Secession, Wien', *Portfolio*, No. 2, Vienna, 2000

Taro, Amano, *Anti-Memory: Contemporary Photography II*, Yokohama Museum of Art, Japan, 2000

Tsering, Lisa, '"into the sun": Impressions of The Bollywood

Dream Machine', *India West*, United States, 21 July, 2000

Van Assche, Christina, 'The "Stalker" of the Fin de Siécle', *Parkett*, No. 57, Zurich, 2000

van Tuyl, Gijs, *Notes for New Religions, Notes for No Religions*, Kunstmuseum Wolfsburg; Cantz, Ostfildern-ruit, 2001

Vergne, Philippe, *Let's Entertain: Life's Guilty Pleasures*, Walker Art Center, Minneapolis, 2000

Vertrocq, Marcia, 'The Venice Biennale: Reformed, Renewed, Redeemed', *Art in America*, New York, September, 1999

Vogel, Carol, 'At Venice Biennale, Art Is Turning into an Interactive Sport', *New York Times*, 14 June, 1999

Vogel, Sabine, *Frankfurter Allgemeine*, Frankfurt, 7 November, 2000

Vogel, Sabine, 'Die Welt im Zwichenraum, Zu Doug Aitkens Videoinstallationen' *Kunst-Bulletin*, Kriens, April, 2001

Wahjudi, Claudia, 'Frau ohne Eigenschaften', *Zitty*, No. 6, Berlin, 8–21 March, 2001

Wakefield, Neville, 'Let's Go to the Videotape', *Art & Auction*, London, 19 October, 1998

Walder, Gabriela, 'Der Grobstadtnomade von Los Angeles', *Die Welt*, 8 March, 2001

Wei, Lily, '2000 Biennial Exhibition', *ARTnews*, No. 5, New York, May, 2000

Weibel, Peter, *Video Cult/ures: Multimediale Installationen der 90er Jahre*, DuMont, Cologne, 1999

Weil, Benjamin, 'Ouverture', *Flash Art*, Milan, May–June, 1994

Willis, Holly, 'Signal To Noise, Doug Aitken's Blow Debris', *LA Weekly*, 8–14 December, 2000

Withers, Rachel, 'Fall Preview: Guy Wired', *Artforum*, New York, September, 2000

Woznicki, Krystian, 'California on the Mind's Road Map', *Japan Time*, Tokyo, 19 July, 1998

Wulffen, Thomas, 'Amor vacui', *Frankfurter Allgemeine Zeitung*, Frankfurt, 26 February, 2001

Yokobosky, Matthew, *Speed of Vision*, Aldrich Museum of Contemporary Art, Ridgefield, Connecticut, 2000

Public Collections

Berkeley Art Museum and Pacific
Film Archive, California
Museum of Contemporary Art,
Chicago
Dallas Museum of Art
Kanazawa City Museum, Japan
Museum of Contemporary Art, Los
Angeles
Walker Art Center, Minneapolis,
Minnesota
Whitney Museum of American Art,
New York
Astrup Fearnley Museum of
Modern Art, Oslo
Centre National des Arts
Plastiques, Paris
Musée d'Art Modern, Centre
Georges Pompidou, Paris
FRAC Haute Normandie, Sotteville
les Rouen, France
Fondazione Sandretto Re
Rebaudengo per l'Arte, Turin

Comparative Images

page 48, **Chris Burden**
B-Car

page 89, **Frederic Edwin Church**
Morning in the Tropics

page 116, **Gordon Matta-Clark**
Splitting

page 89, **Robert Smithson**
Partially Buried Woodshed

page 89, **James Turrell**
Roden Crater

page 116, **Andy Warhol**
Green Disaster Ten Times
Museum für Moderne Kunst,
Frankfurt

List of Illustrated Works

Contents

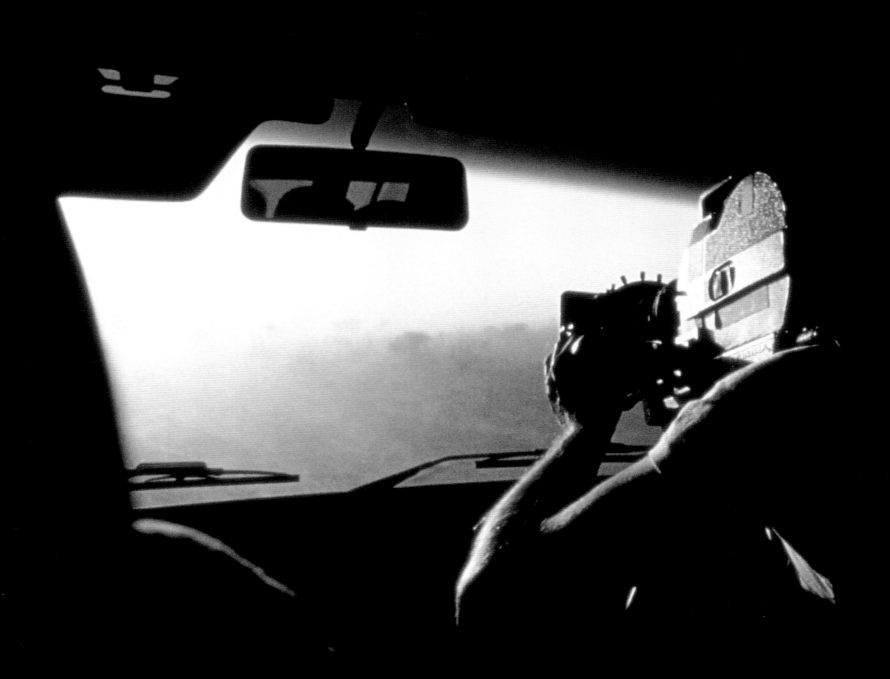

Contents

Amanda Sharp In your work there are many ambiguities: you're simultaneously attracted to and repulsed by certain subjects. Your perspective on reality and time shifts between opposing positions. The trilogy of works *monsoon* (1995), *diamond sea* (1997) and *eraser* (1998) deals with erosion and time moving slowly, whereas your later works *electric earth* (1999) and *i am in you* (2000) are almost advocating a desire to engage with the incredible speed of the information era, where you need to keep moving fast.

Doug Aitken **I'm interested in organic approaches towards making work, structures which move outward in different trajectories and yet share a connection. If I create a work which is intensely human, then maybe the next work I want to make is as far away from that as possible. It is a constantly evolving process of point and counterpoint. Each work must have its own persona, no matter how quiet or extreme. You mention *monsoon*, *diamond sea* and *eraser* as a trilogy, but for me each work is very different despite the connections. *eraser*, in which I walked in a straight line across the island of**

eraser
1998
Colour film transferred to 7
channel digital video installation,
sound and architectural
environment
Collection, Astrup Fearnley
Museum of Modern Art, Oslo
20 min. cycle
Production stills

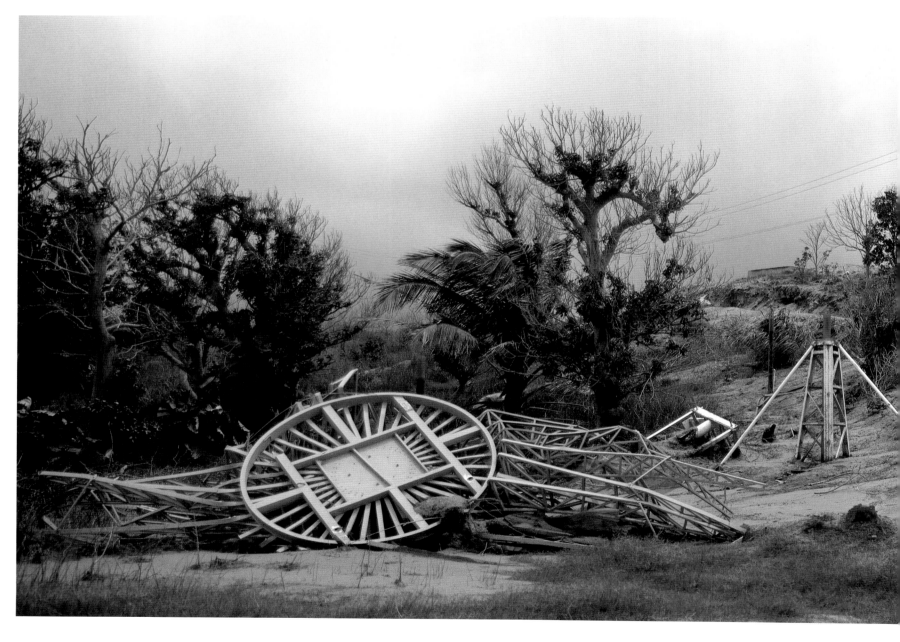

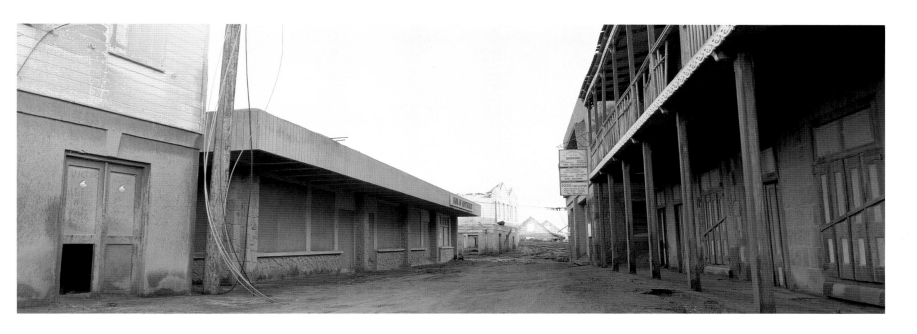

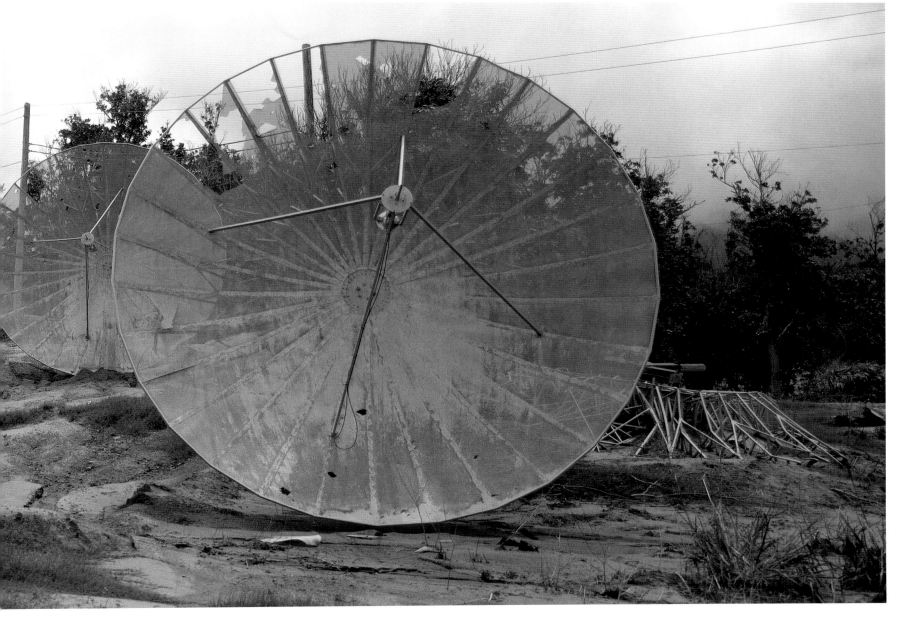

eraser
1998
Colour film transferred to 7
channel digital video installation,
sound and architectural
environment
20 min. cycle
Collection, Astrup Fearnley
Museum of Modern Art, Oslo
Installation, 303 Gallery, New York

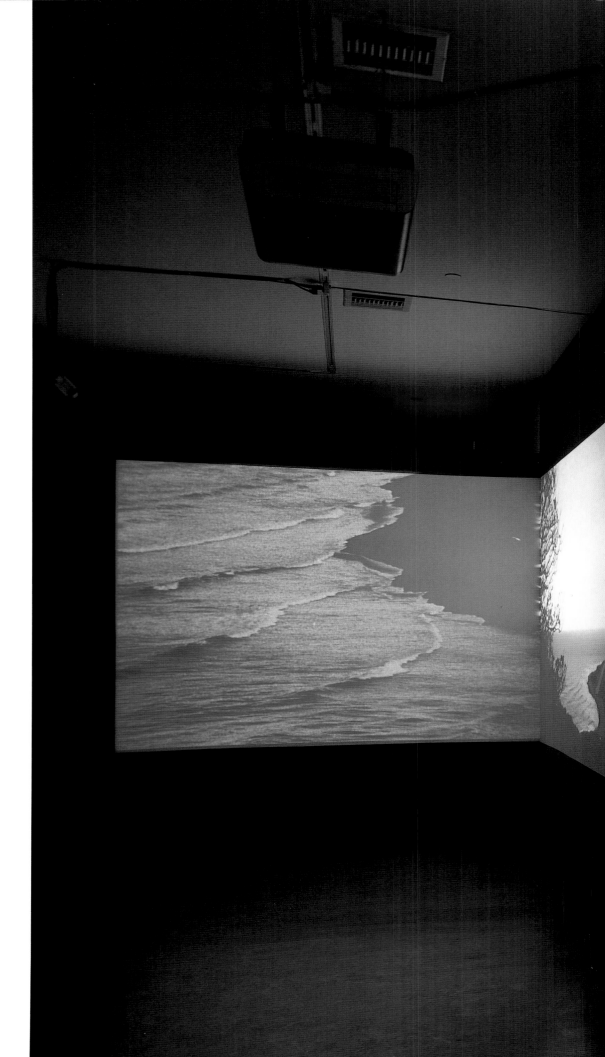

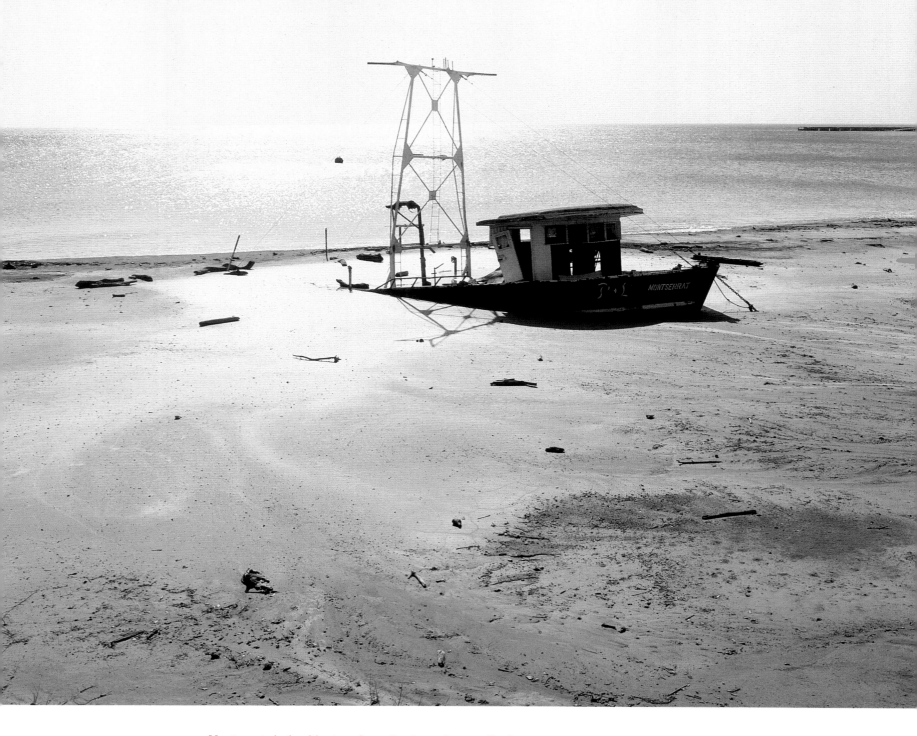

Montserrat, deals with a transformation towards neutrality; in *monsoon*, where I wait for the monsoon to arrive in the Guyana jungle, a negative space and silence create narrative; and in *diamond sea* I just stayed in the diamond mines of the Namib desert for as long as I was allowed, in an attempt to create narrative out of topographical parameters. But there are connections: all three works have at their core the idea of inaction.

Sharp They also share a construction of narrative through documentary. They may have different premises, but *monsoon*, *diamond sea* and *eraser* all follow a similar, documentary-like model.

Aitken It's funny you say that because I see the notion of documentary as a starting point in reality. For me, these works have been transformed into fiction. They're all very much fiction.

eraser
1998
Colour film transferred to 7
channel digital video installation,
sound and architectural
environment
20 min. cycle
Collection, Astrup Fearnley
Museum of Modern Art, Oslo
opposite, production still
below, installation view, 303
Gallery, New York

Sharp When I was looking at *diamond sea*, *eraser* and *monsoon*, thinking about your choice of subject matter, I realized that one possible reading concerned information. For example, no one had been back to the site of the Jonestown massacre in Guyana for six or seven years; it was like a black hole. By going there in *monsoon* you gathered information that was suddenly introduced into 'the loop'; it gave people access to that site again. In the same way, I knew that there had been a volcanic eruption in Monserrat, where *eraser* is set, in 1996–97, but I'd never seen or heard of it again. And with the Namib desert, your location for *diamond sea*, no outsider had entered this barren zone in eighty years. I remember you even said it was literally a black spot on the map. But by going in and recording it, suddenly these places return as part of an information database open to everyone.

Aitken **I think that with these three works, which are all quite location-based, the idea of a history – an event or a situation – has drawn me in, but simply as a departure point, an open door. The process begins when you step through the door; what happens thereafter can often create its own pulse. That is why I see these works as fiction. Each work reaches a point where it functions within its own hermetic, conceptual structure, but after that point the structure is no longer grounded in reality and the work follows its own course. The works are experiments; they are only devices to aid in the transportation of concepts.**

With *diamond sea*, *eraser* and *monsoon* it was important to begin with a very specific structure and then let the work evolve in a more experiential, less predetermined way during the working process. I am constantly piecing things together, finding fragments of information, splicing them, collaging them, montaging them to create a network of perceptions. For many months *eraser*, for example, had a very linear structure; it was just superimposing a straight line on the map. But I think the contrast between superimposing an abstract idea on a landscape like that versus actually being there – having the volcanic dust in your lungs, hearing noises out of the corner of your ear coming from an abandoned silo – is really where perception and the process of creating in 'reel time' merge.

Sharp In all three of these works you didn't know what you would find at the outset. You don't approach narrative like a conventional cinema director or a novelist, plotting the course of events beforehand. Your films physically embody the narrative as it unfolds in space.

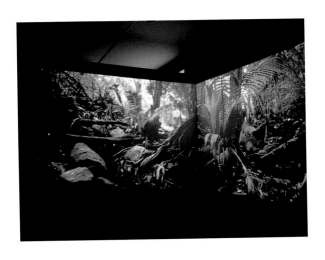

Aitken **In this era of changing perceptions we're responsible for creating new options with which to communicate. Structurally, I'm searching for alternatives. Each work I make is an experiment. I'm not interested in creating projects that illustrate and define; I would rather make departure points, stimuli for questions, provocation. I'm fascinated by the liquidity of time-based media such as sound, motion picture and photography. At times they appear as possibly the most democratic of languages, while at other moments they can slip through your fingers and seem ruled by other forces. I like things that I cannot hold onto.**

Sharp Director Werner Herzog once explained that his book *On Walking in Ice* (1979) came about when he found out that a friend of his was dying in Paris.

Inte

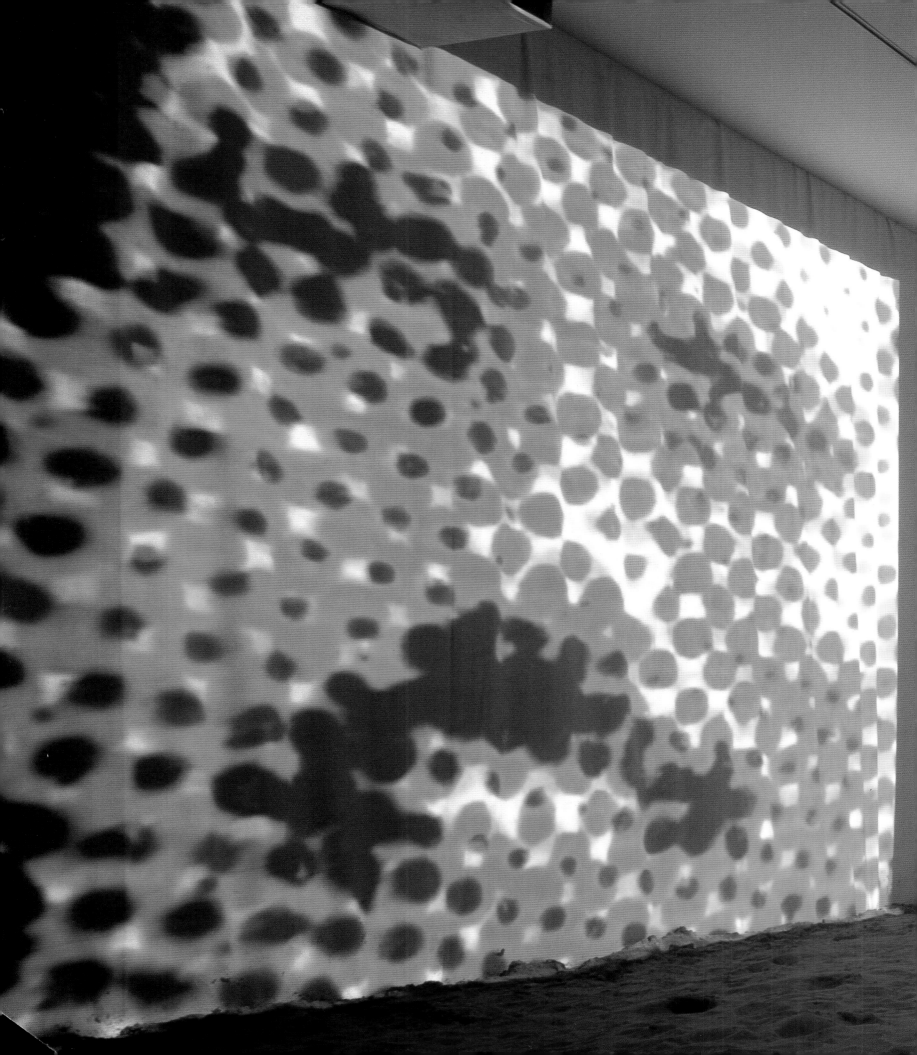

into the sun
1999
Colour film transferred to 4
channel digital video installation,
sound and architectural
environment
7 min. cycle
Collection, Berkeley Art Museum
and Pacific Film Archive, California
opposite, installation, Victoria
Miro Gallery, London
below, production still

Herzog decided that if he walked from wherever he was – I assume Munich – to Paris, his friend lived: he felt he could keep his friend alive by walking. A work like this is about how individuals can attempt to alter – slow down or speed up – time, how they're somehow part of a much bigger system.

Aitken **We all encode our experiences of time at different rates. A single moment from several months ago may consume our thoughts, yet a whole summer five years ago may have completely vanished from our memory. We stretch and condense time until it suits our needs. You could say that time does not move in a linear trajectory, and moreover we're not all following time using the same system.**

When I was twenty-one I worked in an editing room for the first time. We were working long hours, day and night, but for me it was a new sensation, fresh and exciting. When finally I would go home to sleep, my dreams were extremely vivid. As I was moving through a dream, I would look down in the lower right-hand corner of my dream and see numbers: a time code, like the date-time-minute-frame numbers used in editing raw footage. I was surprised that I had never noticed this time code in my dreams before! I also recognized that I no longer needed to watch and witness my dreams passively; I could stop my dream like a freeze frame and look around as if watching a giant, frozen photograph. I could pull back and the dream would rewind so that I could re-assemble it in new ways. That night I re-edited my dreams over and over again.

I suppose my working process is very nomadic. I'm not interested in working out of a sterile, traditional, white-cube studio. I'd like to find a methodology that is constantly site specific, constantly in flux. Some works which are very fictional demand to be built and constructed as if part of a new reality, while others require an intense investigation into a specific landscape. I would like the permanence of my process to be as temporary as possible. I like to think of an absence of materialism where at the end of the day, all one needs is a table, a chair, a sheet of paper … possibly less. That would be nice: to be without routine and unnecessary possessions.

Uprooting and removal surrounds us, and at times these can be mirrored in our working process. At times I just let go and am assimilated into my landscapes, other times I feel an active resistance. I think there's something about growing up in America that makes you feel nothing is ever really stationary. Home can be motion at times.

Sharp How prescriptive do you ever want to be about how the viewer approaches your work? In *electric earth* you construct a structure of scrims which leads the viewer through the narrative. With *i am in you,* you make a circle of screens around a central screen, where the interplay between them is rigourously resolved. Between internal and external spaces there are points where all the screens come together and points where they diverge; yet if the viewers don't sit on the benches you have placed in the installation, they may not realize the screens are in a circle. With *these restless minds* (1998), which involved recording the monologues of professional auctioneers, you created a simulacrum of an auction environment through the use of the video monitors. Although viewers can elect how to negotiate the installation spaces of these works, they're given guidelines as to how to approach them.

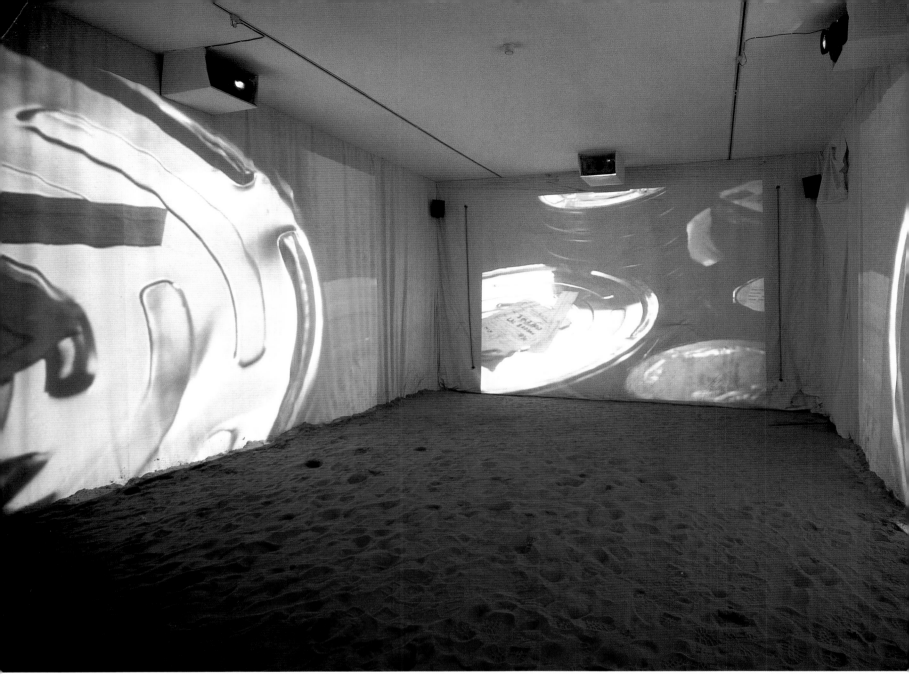

Aitken **The experience of an installation might be different if the viewer moves four or five feet away from where he or she was originally standing. Weighing and unweighing, tension and release all become aspects of the work.**

In my installations I don't see the narrative ending with the image on the screen. Narrative can exist on a physical level – as much through the flow of electricity as through an image. Every inch of the work or of the architecture is a component of the narrative. There are very quiet decisions with specific intentions in my work. I don't wish to control an experience, nor do I want to make something that's merely experiential. I'd rather attempt to set up a system that brings a set of questions to the viewer. I'd like my work to provide nutrients.

Sharp Sometimes you work with found footage and at other times you generate your own images. *into the sun* (1999) is unusual from this point of view; it falls into a grey area. You shot thousands of your own photographs of Bollywood,

into the sun
1999
Colour film transferred to 4
channel digital video installation,
sound and architectural
environment
7 min. cycle
Collection, Berkeley Art Museum
and Pacific Film Archive, California
Installation, Victoria Miro Gallery,
London

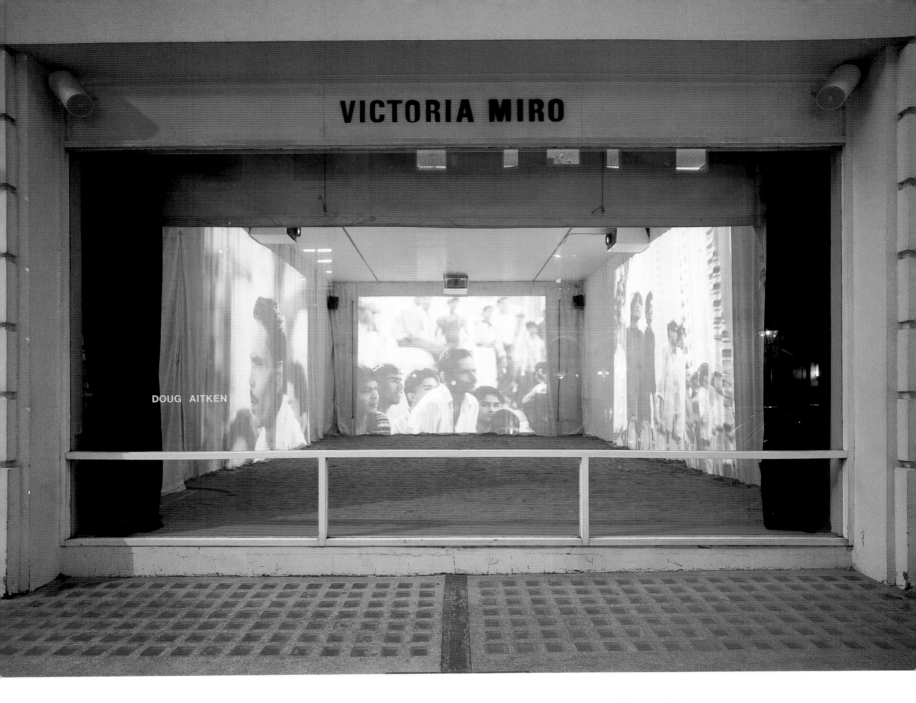

chronicling all aspects of the Indian filmmaking industry, and then used them
to make a moving film.

Aitken In that situation the content revolved around the creation of images,
not around any representation of reality. *into the sun* is a landscape of
thousands and thousands of images of Bollywood: sets, actors, lighting, film,
the processing factories, the unlimited labour force. I was interested in taking
what appeared to be a documentary approach while letting the work slowly
implode. I was interested in this image machine itself, not the final product.
The process of working on *into the sun* led me into a kind of lucid dream of
the audience's collective unconscious, one that was tapped, transferred
straight onto celluloid, and then reflected back at the audience. There was a
perfect connection between the viewers' desires and how they were
mirrored with incredible accuracy in these collective dreams on film. I
realized before I'd left India that the work had to exist somewhere between
the moving and the still image. The work consists entirely of photographs

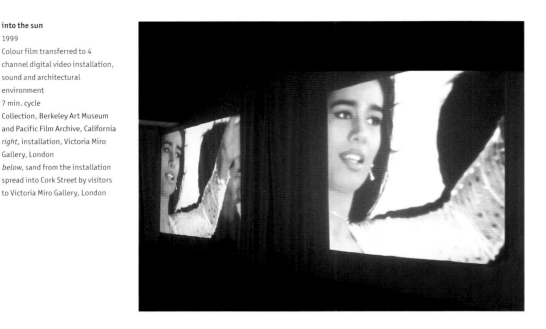

shot in sequence; at times they speed up to twenty-four frames per second. These photographs temporarily come to life, flicker and fall apart again. I did not want the work to flow seamlessly; it had to speed up and slow down, break apart and re-form at its own rate. I wanted *into the sun* to be a flawed illusion, one that eventually collapses in on itself.

Sharp Tell me about your use of found footage.

Aitken **What is found footage? We are losing and finding footage all the time. The information which surrounds us is like a mine; it is our responsibility to actively to dig it out and use it for our own needs.**

 The first work I created using appropriated footage was *dawn* (1993). *dawn* was completely constructed from four moralistic films made for teenagers in the 1970s and early 1980s. When I made *dawn* I was interested in the relationship between media image and personal experience. I felt that before I moved forward to make any new work, I had to reclaim the media I had absorbed when I was young. I wanted to reshape it in a new way, take the experience of passively watching television and reshape the narrative. I decided to edit these four very banal, predictable films, splice them together and create one film with a narrative that could move in a new direction, away from any of the films' original intentions. I wanted to gain control of the destiny of the characters and assist them into situations and places they could

dawn
1993
Single channel video of
appropriated film and video,
colour and black and white, sound
6 min. cycle
Video still

never have gone in the original films. Through the process of re-editing, *dawn* became an exercise in transforming the dormant energy of the media image.

Sharp Surprisingly few artists are dealing with the way the media and technology have become the landscape of our lives, how speed and information are changing everything. When you look at the main character Jiggy moving in *electric earth*, he could be typing; his movements are almost binary – an either/or option in direction which snaps into place like a synapse. He could be a character out of a William Gibson novel.

Through travel we often visit areas where we don't plan to stay. They're outside of our usual experience; we're travelling to another experience. We're migrant workers nowadays, people living the facsimile of a jet-set lifestyle without necessarily earning jet-set incomes.

Aitken **Yes, maybe; at times our feet become wheels, our arms jet wings. The culture is mobile, but then again there are many, many people who aren't**

moving much at all. Information moves to them. This is one of the strange situations that I have observed: motion becomes relative after a while. What is moving, us or our surroundings?

I once met George Clinton. He's a funk musician from a band called Funkadelic, a nice guy who mostly speaks in this space-age-like language he has created. He was playing in Las Vegas at a venue on the strip. Clinton arrived in a limousine and I asked him if he was staying at one of those shimmering crystal hotels. He said no, he preferred a cheap Day's Inn in the dilapidated part of the city. For the past twenty years on the road, George Clinton only stays at Day's Inn motels, because throughout America every Day's Inn room is exactly the same: the carpet colour, wallpaper pattern, even the angle of the bed and coffee table. Clinton was searching for a sense of familiarity when he awoke each morning, disoriented from months of touring; he needed to know exactly what the room he was in was like.

In Asian culture you could say that traditionally, through custom and ritual, one slows down deliberately, just for the sake of slowing down. But in Western culture, we speed up to slow down. We seem to be living in an environment that erases its past with a flood of information in the present. Are we attempting to reach a state of nirvana through the over-saturation of information? Is there a point of neutrality, where perception becomes lucid and slow, when one has reached full capacity?

Our blueprints for perception are in constant flux and, as in the design of any construction, there are tests. The test for these blueprints seems inconclusive.

Sharp So I suppose my earlier comment, that by accessing the volcanic landscape of Montserrat or the diamond mines of the Namib desert you are returning that data to our collective data bank, isn't true?

Aitken **I don't feel these works necessarily take places as if they were documents, unearthing them and bringing them to the table for examination. If I'm presenting data, it is without resolution … to question and not to conclude.**

Sharp Can I ask you about your work where you swam the Panama Canal asleep?

Aitken **In *the longest sleep: pacific ocean – atlantic ocean, swimming the panama canal asleep* (1999) I swam across the Canal incrementally. I wanted to experiment with an in-between space. I suppose there's a quiet, unconscious level to that work but also this absurd desire for connection. I often find myself attracted to situations which initially I feel are impossible or improbable; I am drawn to processes that promise no security. At times this puts me in a position where the work must be willed into existence.**

Sharp You have taken a lot of photographs.

Aitken **I have a restlessness with the way a photograph captures time. It's fascinating to me, yet I feel I want something more from the formalism of the medium itself. The static quality of the 'frozen' image or 'decisive moment' is not enough. I want non-decisive moments, inactions, what has happened before or what is to come. I would like to smash a photograph, open it and**

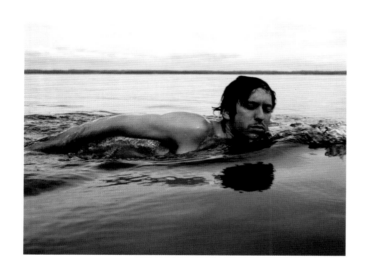
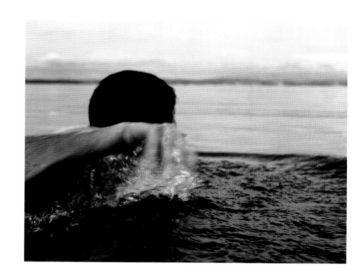
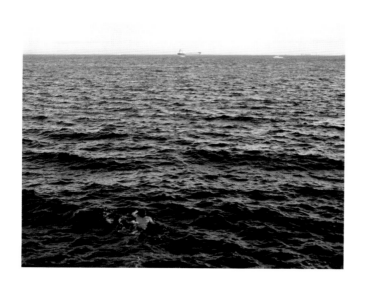
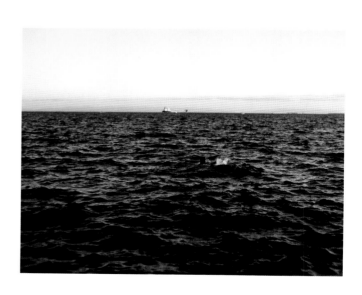

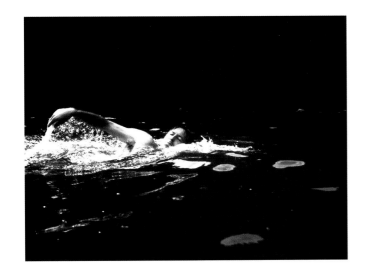
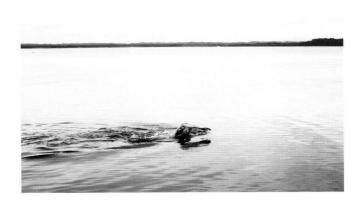
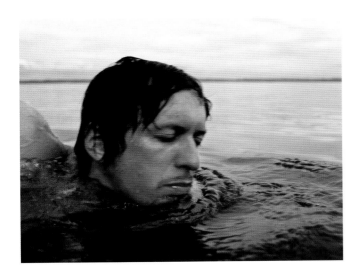

see what's inside. Maybe then this so-called 'frozen' time could expand and contract. In that sense images are like liquids.

Photographs, sound works, installations, film, happenings are all just vessels to be filled. I use a medium only when it's absolutely necessary.

Sharp How do you approach your soundscapes?

Aitken The area for a conceptual use of sound is so vast. In every project I attempt to approach sound in a different way, creating audio structures that are unique to the concept. I often see the sound in these works as language. Some situations have been attempts to work hermetically with the subject matter; in *eraser*, for example, I wanted to document every sound on-site in Montserrat and create an immense library of field recordings. These sounds were then transformed – stretched out, looped, re-assembled – to create patterns and tempos. The locations and intrinsic sounds became a kind of audio DNA structure.

With *i am in you* the approach to sound was radically different. It was completely reductive. In any given moment, a cacophony of sounds surrounded the viewer. I wanted to slice away the layers of audio to create an organic minimalism: the incredible macro-sound of a beam of wood twisting and knotting to a point of snapping, or the sound of an electrical surge crackling and transforming into the rhythmic sound of clapping hands. In *i am in you* the sounds were like signals or beacons of light.

Sharp Sound seems to play a key role in the installations; for example in *diamond sea* there's an enormous score. In a way that's closer in spirit to the working methods of an avant-garde or experimental filmmaker than most gallery-based artists.

Aitken I like to create sound as raw concept. I'm always finding particles of information through listening, whether it's the sound of the wind as it whistles through a crack in my car window, or the white noise of subway chatter. Just close your eyes in a bus station and listen, just listen. Just listen … someone says 'What did you do yesterday?' Narratives are being written all around us. They're in the air. I feed off these experiences.

Sharp Can you tell me about *blow debris* (2000)?

Aitken In *blow debris* I was interested in exploring cycles of change as if any given moment could open up onto a multitude of levels. The beginning of the work is open and atmospheric; flares of sunlight shooting into the camera. We are in open, expansive desert-like terrain. Groups of people, naked and unfamiliar with the uses of the broken relics of modern civilization strewn about them, almost merge into their environment. Individuals slowly leave the group and travel alone.

The work follows different progressions and narratives exploring the constant degeneration and regeneration all around us. Individuals find themselves in the isolation of these experiences. As they move through their surroundings, they are caught in a cycle of constant transformation.

Throughout the piece a constant sense of turmoil manifests itself, sometimes quietly and subtly, at other times in a more direct and immediate

right and following pages,
blow debris
2000
Colour film transferred to 9
channel digital video installation,
colour, sound and architectural
environment
21 min. cycle
Production stills

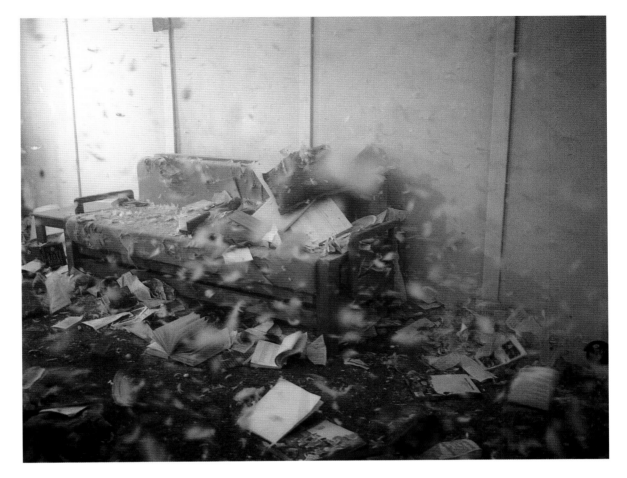

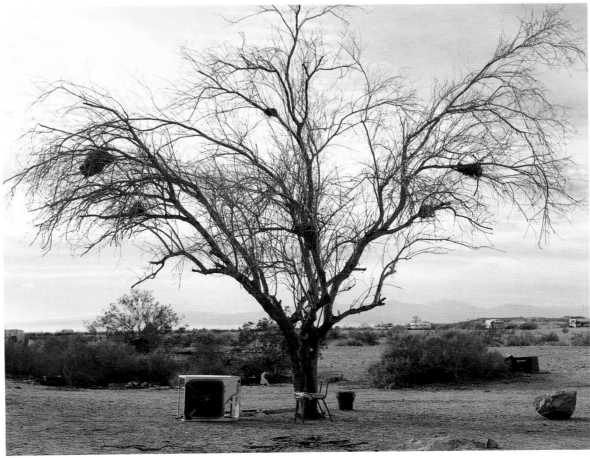

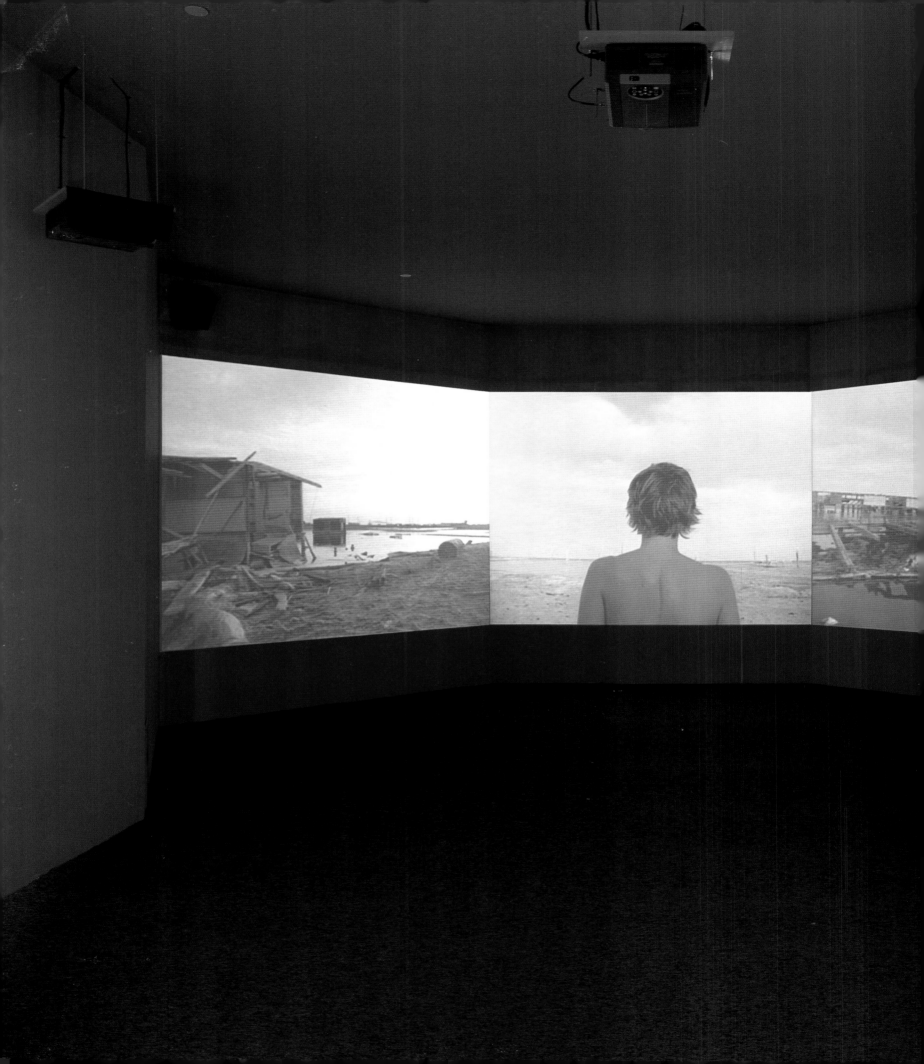

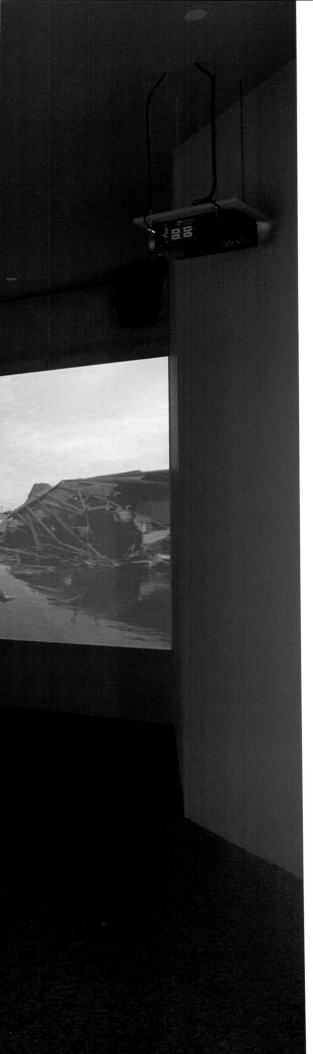

left and following pages,
blow debris
2000
Colour film transferred to 9
channel digital video installation,
colour, sound and architectural
environment
21 min. cycle
Installation, 'Flight Patterns',
Museum of Contemorary Art, Los
Angeles

way. We follow each individual in an entirely separate narrative. Although there is a sense of a connection, it only really emerges in the final scenes, where the progressions tighten and become increasingly ordered. We see an aerial view of suburban housing projects stretching far into the horizon in grid-like symmetry. The individuals we have followed are inside these homes. We sense psychological space narrowing to a finite point. The intense atmosphere earlier in the work is condensed to images of a man flinching his eye, or fingers caressing a kitchen table. We are pulled into a vortex of shifting information, but as this happens in a quiet, almost silent way we begin to notice cracks and inconsistencies. The side of a chair is starting to flake off and turn to dust, filtering through the air into the skin; layers of skin become dust, leaving a DNA trail across a room. In the final scenes, real time seems to accelerate into a process of erosion. The chair disintegrates. The light in a room moves in beams and starts to glow; the room is now a bank of light. The process of deterioration speeds up dramatically. The protagonists begin to dissolve in a cyclone of sand and swirling dust. Everything we see manifests change. All information is caught in a state of flux, graceful and weightless but at the same time violent. It reaches a point where all the components are moving faster and faster, but they begin to fall out of sync. Change occurs on different levels, moving at different rates through time. An object, maybe a lamp or a chair, explodes; meanwhile another object right next to it spins slowly. Relationships with time start to break apart and create faulty connections. Psychological space becomes a flat line.

There is chaos until finally nothing is visible. Everything is white noise. Gradually objects begin to slow down and reverse themselves. Everything slowly returns to its original shape. As the debris falls back as it was, we realize no human presence is left.

In this piece I didn't want to work with traditional actors and actresses. I wanted a direct connection with the individuals with whom I was working. It was a long process to find people who could mould their persona to fit into the trajectory of the work. I needed a kind of community of people for several scenes, and I found a squatter community called Slab City in the Mojave Desert (California). They live in the remote, warm foothills of the Chocolate Mountains, a location falling between government jurisdictions, a kind of legal black spot without taxes or police. You can find between a hundred and two thousand people in Slab City, depending on the season. Some are completely homeless, others live in campers.

For the particular language that I wanted to create in *blow debris* I needed to work at length with some of these individuals. It was a situation in which things could be misread: I was seen suspiciously, as an outsider, someone with film equipment, someone not to be trusted. At times there can be violent resistance, but I had to create a bridge. It took a while before I had their trust; both sides had to offer a level of vulnerability.

Traditionally, film has a degree of distance or safety from its content. I think about this separation sometimes; I am much more interested in either a zero or an infinite distance between the content of my work and myself.

Sharp Could you ever imagine working within the stricter parameters of conventional film, like the 90-minute boundary, for a different audience?

Aitken **Cinematic conventions, like 90- or 120-minute films, have become the**

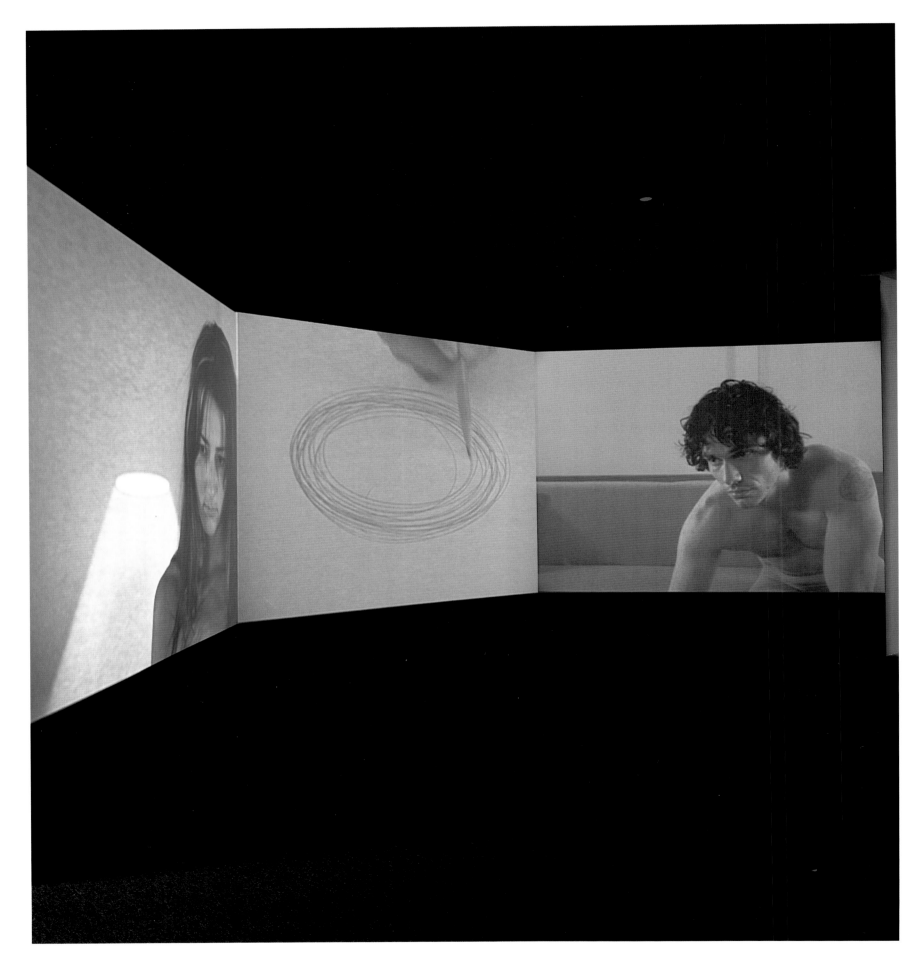

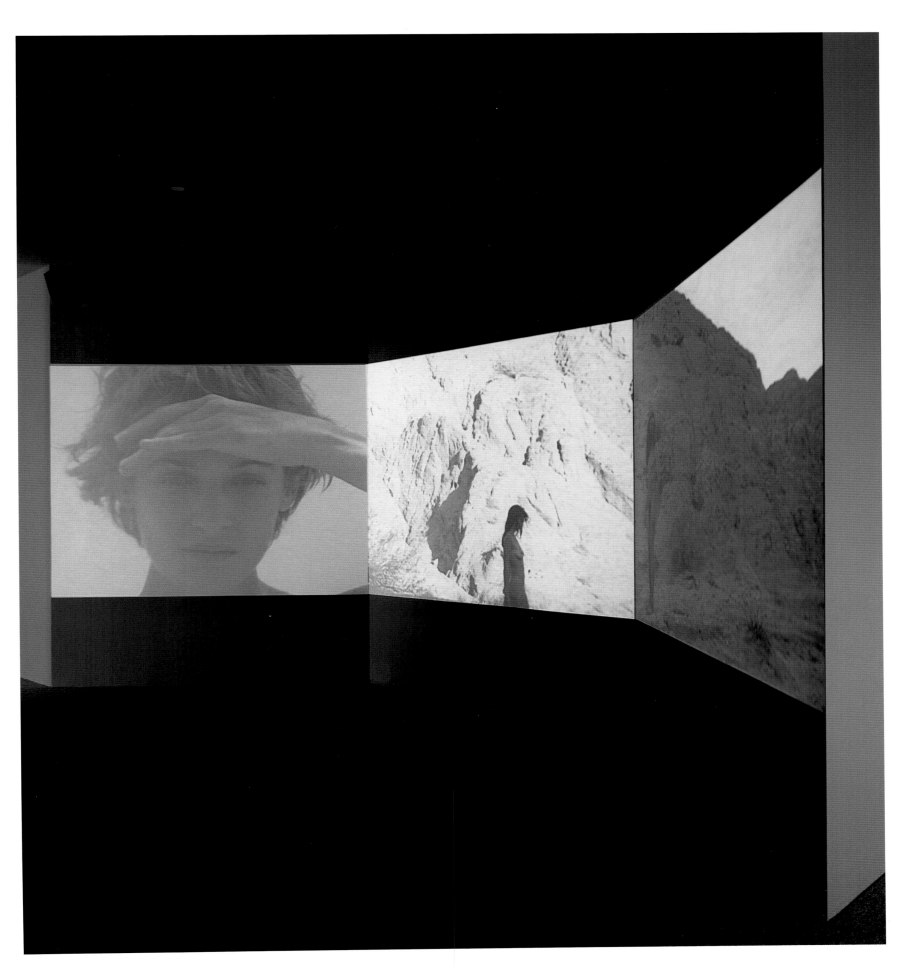

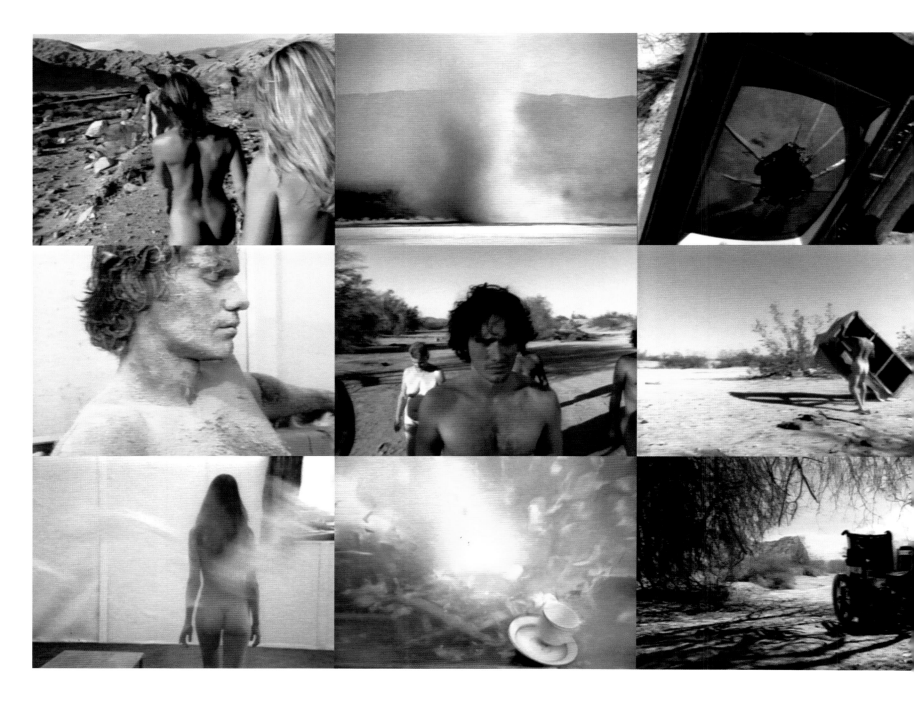

blow debris
2000
Colour film transferred to 9
channel digital video installation,
colour, sound and architectural
environment
21 min. cycle
Video stills

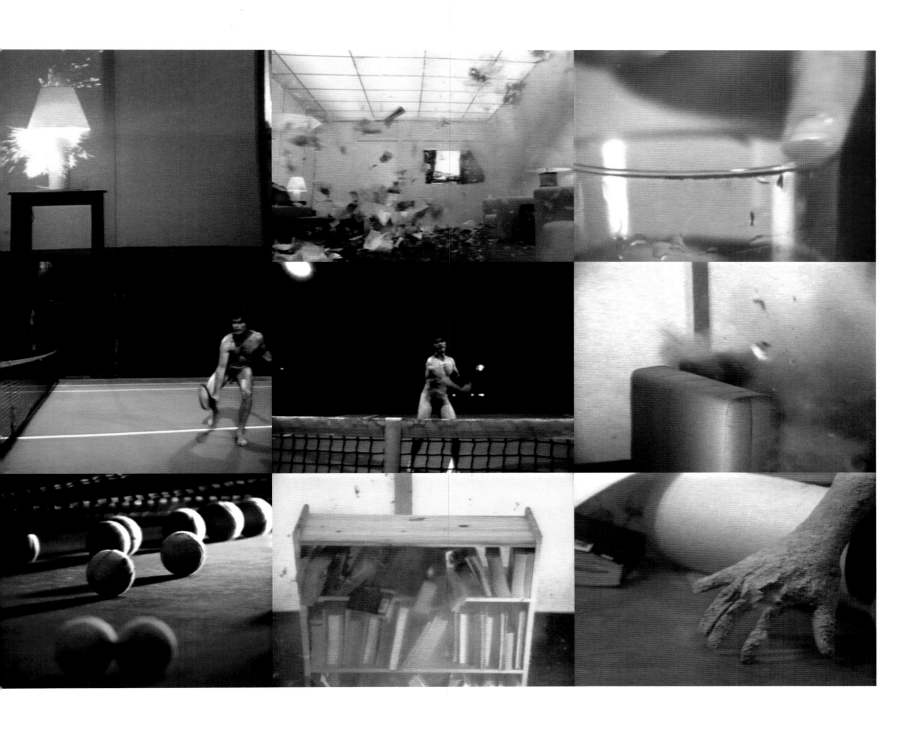

33 Interview

legacy of the twentieth century. There's always going to be room to work within those parameters, but for now I'm more interested in new and different systems to be created.

Sharp In your work, at what point do you start thinking about the way that a film will be installed?

Aitken With a work such as *i am in you*, I wanted to create and develop these two sides, the film and the installation, simultaneously. While I was writing and executing the concept – that is, while I was filming – I wanted to experiment with architectural aesthetics: the different screens, translucencies and materials. For a while when I was making *i am in you* the processes were co-existing almost one-to-one.

With *eraser* I knew the walk across the island required a strong progression in its installation. I knew it had to be a deconstructed architectural situation where the experience of the work mirrored the walkabout. In *these restless minds* the auctioneers needed to 'step off the floor', the monitors placed above ground level, onto a platform or podium that's almost like the kind you'd find them on at an auction.

I once happened to meet and chat with an auctioneer in a parking lot in Ohio, and that's how *these restless minds* came about. We were talking about reaching a point where the voice becomes unintelligible. Where is that threshold where voice and language and ideas become just a frequency? How fast can perception move? How fast can you input and output information? This auctioneer I was talking to, Eli Dotweiler, said there's something called a 'chant' that we all have, although we are generally not aware of it. The chant occurs when you talk so rapidly, as an auctioneer does, that language begins to break down and there is only white noise, chaos. When your language continues to accelerate and you listen to this high-speed, post-linguistic sound you begin to hear a certain tempo and rhythm. This is called the 'chant', a rhythm that emerges after language has deteriorated. Every human being has a slightly different rhythm to their chant. We're not all aware of it, but in each of us the chant is as distinct and unique as a fingerprint or DNA imprint. When the chant occurs, it's like

these restless minds
1998
Colour film transferred to 3 channel digital video installation, sound and architectural environment
8 min. cycle
Collection, Dallas Museum of Art
below, Installation, 303 Gallery, New York
opposite, Installation, 'Let's Entertain', Musée d'Art Moderne, Centre Georges Pompidou, Paris

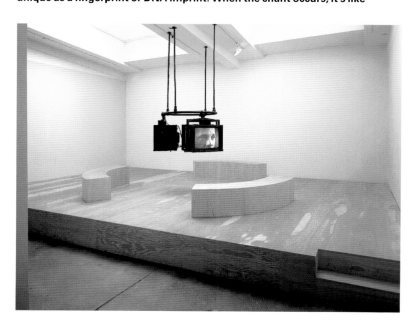

unlocking a new door: you discover an internal rhythm and realize that there is a certain unique cycle that we each follow. In *these restless minds* I became very interested in this idea of the chant and also finding where perception goes after it has passed the limits of language, ideas and communication.

Sharp It was strange to hear some of those chants, with rogue elements like the description of sunlight entering into the monologue.

Aitken **I wanted to create a connection between the speakers and their surroundings. I'd asked them to step back from their routine and do two unfamiliar things. First, to do numerics, cycles of the numbers 1,000 and zero as fast as humanly possible, or counting from zero to ten over and over, forever and ever. The numbers were interspersed with their raw perceptions describing their immediate environment. They were situated in very ordinary places which were part of their everyday lives, very banal settings, vast parking lots, revolving escalators or rows of unused pay telephones just before the sunset. I wanted perception to pull information in, like a vortex.**

Sharp It was interesting when you brought the three sisters, all professional auctioneers, together in that work, because they looked the same but sounded very different, and they played it out as though they were having a normal conversation together, yet they sounded automated.

Aitken **The three sisters were like birds: I didn't take them out into the parking lot where we recorded; they just happened to land there. I happened to meet them while we were shooting, and brought them into the project. When I saw them on film, I realized that I hadn't really met them at all. It was as if they'd just surfaced, for thirty minutes at dusk one day in Ohio, in the parking lot of a Wal-Mart, and started to talk. I hate those terms like 'post-human' which seem so cold and cynical, but I think there's something about those three sisters which is maybe pre- or hyper-human. There's something that I just really loved about them, they were so human, they became almost alien. I had to step back from the camera at one point and watch them. I gradually closed my eyes, let the camera roll, and just listened ...**

these restless minds
1998
Colour film transferred to 3
channel digital video installation,
sound and architectural
environment
8 min. cycle
Collection, Dallas Museum of Art
Film stills

Contents

below, left, **kite**
1993
Black leather kites,
photosilkscreen acrylic, wood,
steel
Dimensions variable

below, right, **accelerator for
seasonal change**
2001
Anatronic branch with cloth
leaves and flowers, pulleys, cable,
time synchronizer
Dimensions variable

opposite, **inflection**
1992
Colour film transferred to video,
sound
13 min. cycle
Video stills

*The brain has lost its Euclidean co-ordinates, and
now emits other signs.*
Gilles Deleuze, *Cinema 2: The Time-Image*[1]

A married couple, both truck drivers, spend night
and day in the same vehicle, constantly travelling
across the American continent. While one drives,
the other tries to get some rest. The woman prefers
driving at night; the roads are empty, and an
extraordinary change takes place. Each night the
landscape is as if transformed into a film playing
on the large windscreen of the truck. The wheels
are like the reels of a film projector, and on the
driver's seat, this magical cinema's sole viewer
can enjoy in splendid isolation the spectacle of
thoughts and memories on the windscreen. Doug
Aitken – who met the couple at a diner in
California – told me about this nocturnal
metamorphosis, and it struck me that similar shifts
happen in his own works. Take the early video
piece *inflection* (1992), produced by launching a
film camera, attached to a small, high-powered
rocket, into the sky. Here, essential elements of

Aitken's work are already present: a moving
vehicle; speed made tangible; an abstract
landscape unfolding through contemporary
technologies of vision. Initially one sees the blue
of the sky, then the white rocket's elegant slim
body. As it takes off, the camera is turned
downwards, registering the texture of the ground.
It takes a while to understand that the grainy
surface is the asphalt where the launch took place,
but then things become clear: a parking lot, a few
cars, some buildings, a highway. The camera
spirals into the sky. Each time it spins we witness
the same constellation of buildings and roads –
only the cars have moved, and everything is
smaller and further away as the ground map
expands. When exhibited, the film (transferred to
video) is played in extreme slow motion. Frame by
frame the urban landscape of southern California
unfolds before our eyes: the ordinary features of
the suburban grid appear as an enigmatic pattern.

The landscape as seen from a moving vehicle
recurs throughout his works. In *autumn* (1994),
the view of the clouds from an aeroplane window

inflection
1992
Colour film transferred to video,
sound
13 min. cycle
Video still

returns several times as an interval of sublime stillness. The wing and the jet motor seem to stand still; the distant landscape of clouds moves with glacial slowness. Other vehicles make their appearance: a car, a bicycle, a human body. Everything moves smoothly, glides and drifts in perfect sync, as in a music video liberated from all restrictions and free to concentrate only on ambience and flow. From the very beginning, Aitken's works have referenced speed and motion. This links his endeavours to an older generation of Californian artists interested in aviation and cars, from James Turrell and Chris Burden to Robert Irwin. The experience of driving on a Californian freeway – the feeling of freedom and the pleasure of frictionless motion – has found many expressions, among them Irwin's jubilant report after returning to Los Angeles from a trip to Japan: *'I was driving over Mulholland Pass on the San Diego freeway, you know, middle of nowhere at about two o'clock in the morning, when I just got like these waves – literally, I mean I never had a feeling quite like it – just waves of well-being. Just tingling. It's like I really knew who I was, who I am ... To ride around in a car in Los Angeles has become one of my great pleasures.'*[2]

Aitken belongs to perhaps a less euphoric generation, but the sensation of driving a car and the experience of moving in vehicles is no doubt of importance for his art, as is the very concept of speed. Another unmistakably Californian project, in many ways related to *inflection*, is the high-speed video *fury eyes* (1994) which documents daredevil Ron Fringer's attempt to drive a motorcycle down a racetrack at 190 miles per hour.

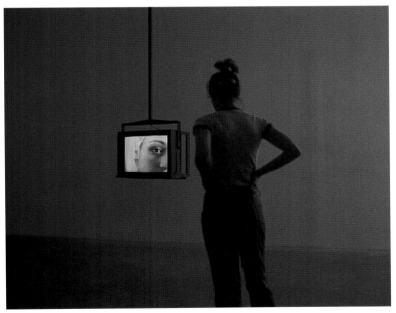

autumn
1994
Single channel colour film
transferred to digital video, sound
with three monitors
8 min. cycle
opposite, video still
top, production still
bottom, installation view, 303
Gallery, New York

fury eyes
1994
Single channel colour and black
and white digital video, sound
7 min. 30 sec. cycle
opposite, video stills
below, installation view, **american
international** (with Duratrans
backdrop), 303 Gallery, New York,

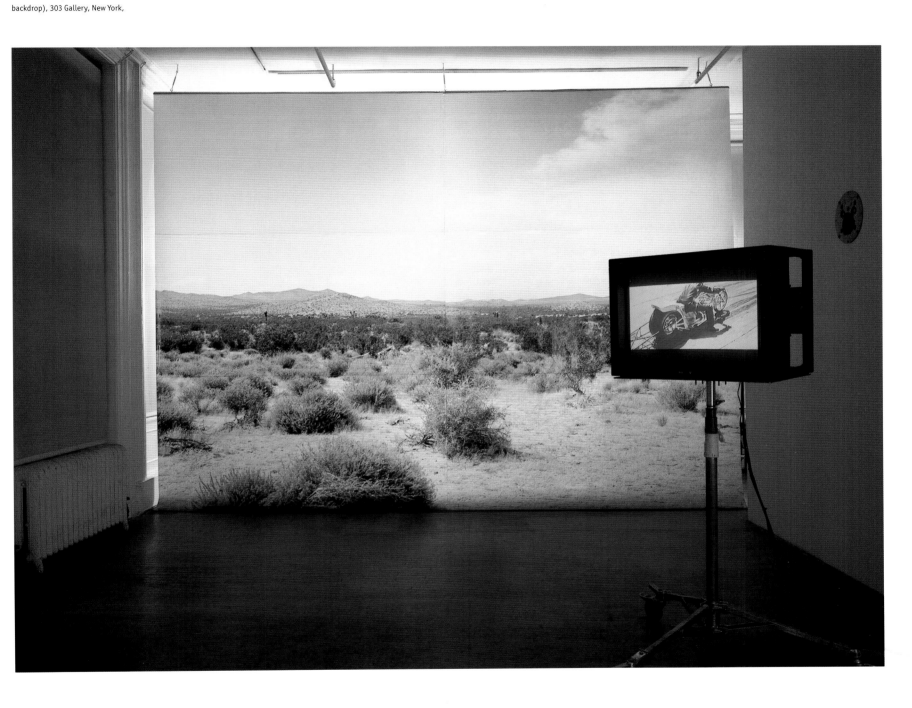

Chris Burden
B-Car
1975
Mixed media
78.5 × 270 × 122 cm

opposite, **diamond sea**
1997
Colour film transferred to digital
video, 3 channels, 3 projections, 1
monitor, Duratrans backdrop,
sound and architectural
environment
10 min. cycle
Collection, Museum of
Contemporary Art, Chicago;
Walker Art Center, Minneapolis,
Minnesota; Centre National des
Arts Plastiques, Paris
Production stills

However, the camera attached to the vehicle breaks down before full speed is reached. Instead of a transcendence of motion hoped for by a whole tradition of predominantly male artists, a technological disruption sets in. Unlike Chris Burden's playful *B-Car* (1975), say, most of the motorized vehicles in Aitken's videos belong to a post-mechanical era and will inevitably collapse. It would appear that it's only their disintegration that comes close to expressing what the artist, in many of his works, is trying to capture: a rich sense of time and narrative structures elaborate enough to give expression to heterogeneity and complexity.

In a world where tele-presence and tele-robotics are no longer just the ingredients of science fiction novels or utopian visions but features taken for granted in our everyday lives, the very concepts of place, movement and velocity must be renegotiated. In the global omnipresence produced by today's digital technologies, time no longer follows a linear order of successive moments. Rather, it becomes, in the words of Paul Virilio, 'a system of representation of a physical world where future, present and past become interlinked figures of underexposure, exposure and overexposure'.[3] Throughout the 1990s, Aitken's works have systematically explored the perceptual, narrative and poetic possibilities opened up by the global environment produced by new technologies of communication. In a world brimming with digital information, we have moved beyond the age when machines are seen primarily as extensions of the muscular system. Today's technologies are methods of extending the

nervous system beyond the traditional confines of the human body. They seem capable of altering the very core of experience – the perception of a continuous flow of events across time.

The conventional conception of time in the Western tradition, in science as well as in philosophy, has been that of a line of now-points. The recurring images for illustrating the structure of temporality – from Aristotle's *Physics* all the way to Edmund Husserl's phenomenology of time-consciousness – is that of the point and the line. Husserl's famous metaphor is that of the comet's tail: what is present in the strict sense is the burning comet itself, whereas the past, seen as a long series of now-points gone by, makes up the radiant tail which tapers into invisibility and finally oblivion. The idea of a moving body – be it a comet, a truck or a high-powered model rocket – functioning as an illustration of time is, it seems, as old as the very concept of linear time itself. But this linear notion of temporality is also something that some thinkers as well as artists have endeavoured to overcome, and Aitken is clearly among them. Early works such as *inflection* and *fury eyes* seem to push the linear model – a vehicle travelling at extreme speed, vertically or horizontally – to its limit, and beyond. In later installations, the struggle to dismantle linearity has led to new distributions of time and space, producing intricate labyrinths of folded space/time. The elaborate system of flows and pulses in works such as *diamond sea* (1997), *electric earth* (1999) and *into the sun* (1999) cannot be reduced to a linear narrative, let alone to a clear temporal succession. In an

 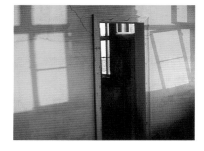 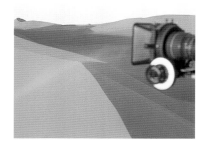 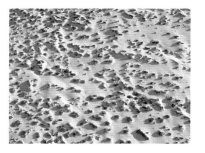

 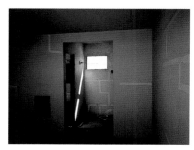 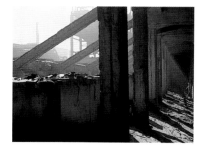 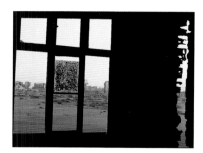

diamond sea
1997
Colour film transferred to digital
video, 3 channels, 3 projections, 1
monitor, Duratrans backdrop,
sound and architectural
environment
10 min. cycle
Collection, Museum of
Contemporary Art, Chicago;
Walker Art Center, Minneapolis,
Minnesota; Centre National des
Arts Plastiques, Paris
Production stills

interview, Aitken discussed the problems of expressing an alternative, more complex, understanding of time: '*Film and video structure our experience in a linear way simply because they're moving images on a strip of emulsion or tape. They create a story out of everything because it's inherent to the medium and to the structure of montage. But, of course, we experience time in a much more complex way. The question for me is, "How can I break through this idea, which is reinforced constantly? How can I make time somehow collapse or expand, so it no longer unfolds in this one narrow form?"*'[4]

Aitken often returns to the importance of finding new and richer models of narration, and, as a consequence, new ways of approaching temporality. In recent installations it is no longer a question of pushing the linear model of time to the verge of collapse, but rather of suggesting more sophisticated and complex networks that allow for temporal heterogeneity in a multiplicity of non-synchronous connections, delays and deferrals. Such maze-like temporalities – by necessity always thought of in the plural – have been contemplated by philosopher Gilles Deleuze in his study *The Fold: Leibniz and the Baroque*.[5] Time should not be seen as a line of successive points, but rather as an intricate structure of bifurcating and divergent series, or in the words of novelist and poet Jorge Luis Borges, as a 'Garden of Forking Paths'. In his story by this name Borges alludes to a Chinese architect and philosopher, Ts'ui Pên, who does not believe in a uniform, absolute time: '*He believed in an infinite series of times, in a growing, dizzying net of diverging, convergent and parallel times. This*

network of times that approached one another, forked, broke off, or were unaware of one another for centuries, embraces all possibilities of time. We do not exist in the majorities of these times. In some you exist, and not I; in others I, and not you; in others, both of us.'[6]

Aitken's most ambitious installations construct such multi-temporal worlds; they harbour not one flow of events but a labyrinth of diverging paths, each with its own pace and temporality. His various projects relate to each other according to a peculiar logic of deferral and return: motifs travel from work to work and create a curious web of thematic connections. Some of the themes that can be traced are: an intense interest in landscapes verging on abstraction; various forms of automation that seem to efface the clear border between the organic and the artificial; the processes of perception and temporal awareness relating to today's technologically altered environments. An ambitious work that negotiates all of these issues is the multi-screen installation *diamond sea*, shot during several weeks in the Namibian desert, southwestern Africa. It started with the artist's puzzlement at a huge blank section on a map of the southern 'skeleton coast'. Trying to gather information about this zone, all the artist could learn was that it is known as Diamond Area 1 and 2, and that it has been sealed off from the rest of the world since 1908. Behind the computer-controlled fences lies a vast territory – more than 70,000 square kilometres – that contains the world's oldest desert, the Namib, as well as an enormous diamond mine. Aitken's camera registers smooth banks of sand, lines of

diamond sea
1997
Colour film transferred to digital
video, 3 channels, 3 projections, 1
monitor, Duratrans backdrop,
sound and architectural
environment
10 min. cycle
Collection, Museum of
Contemporary Art, Chicago;
Walker Art Center, Minneapolis,
Minnesota; Centre National des
Arts Plastiques, Paris
opposite, installation, 303 Gallery
New York

undulation produced by the wind, and sharp shadows contrasting fields of complete darkness with those of the red-hot desert sand. The landscape, with its distinct and almost stylized shapes and lines, displays artificial qualities. At times it seems to transmute into an image – an image of emptiness, verging on abstraction. In a discussion with critic Francesco Bonami, Aitken expounds: '*Of the five weeks I spent in the "zone",* *the geographic barriers that restricted the space* *made up the narrative. The landscape itself provided* *an immeasurable emptiness, a straight horizon line* *dividing sand, sky and ocean.*'[7] In the midst of the vast emptiness, almost entirely devoid of people, a highly sophisticated mining industry is at work around the clock. The intelligent machines seem to function independently of any human involvement. They dig for diamonds, transport sand and rocks, and even survey the territory, protecting their property aggressively. The camera pans fences, metallic scaffolding, an excavator; it zooms in on surveillance cameras and registers a huge black helicopter hovering with the rotor flapping in slow motion. Even if nothing really happens beyond the automated movements, the whole industrial complex exudes an ominous and threatening atmosphere. As critic Jörg Heiser remarks, these machines operating in the sun make you feel that 'this is not only restricted, but contaminated ground, contaminated by colonization and greed'.[8]

It is the very contrast between nature and technology that becomes the theme of the piece, and Aitken takes pains to present the scenery, in slow takes of vastness, interwoven with computerized machines – without making his own

moral point of view felt: '*The camera became a* *silent eye focused on capturing light and space from* *a non-judgemental perspective. Here the focus was* *on something incredibly elusive. In its installation* *form, the work cycles without beginning or end.*'[9] We see the rusty underbelly of a truck and barbed wire, then we see wild horses running freely through the desert, rolling in the sand. We see the mechanical movements of a surveillance camera and we get a close up of a horse's eye, blinking in the sun. Even if the contrast between nature and machine represents a clear tension in the work, it's the general mechanization, involving the industrial devices as well as the landscape, which makes the strongest impression, pushing *diamond sea* beyond the traditional nature/culture divide. The cycles of nature – the sun, the waves – are not necessarily in opposition to the artefacts exploiting the natural resources. On a more speculative level, all movements seem to participate in the same iterative process, which is perhaps a cycle of death rather than of life. Nevertheless, the wild horses running through the desert still represent life, and the grasshopper on a wall is alive even if it behaves almost mechanically. The very few humans seem to be reduced to serving the elaborate machinery. It is as if the automated industrial complex is animated yet devoid of life. Everything organic, as Freud claims in *Beyond the Pleasure Principle,*[10] has the inherent drive to return to an earlier and more fundamental state of existence: that of the inorganic. Life is but a detour between an original state of death and a future death to which everything alive is essentially striving. Freud first

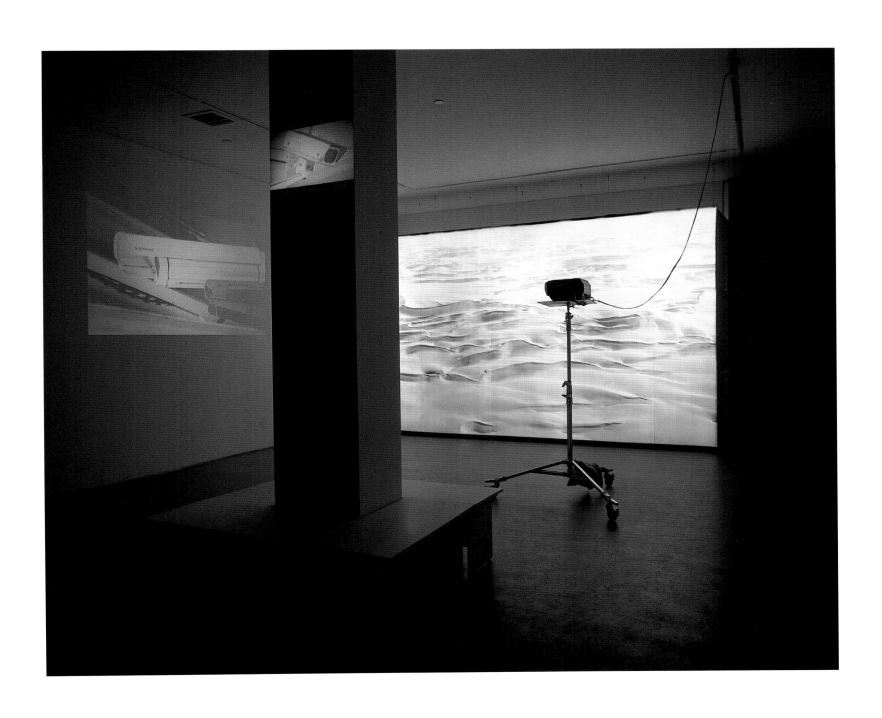

diamond sea
1997
Colour film transferred to digital
video, 3 channels, 3 projections, 1
monitor, Duratrans backdrop, sound
and architectural environment
10 min. cycle
Collection, Museum of
Contemporary Art, Chicago; Walker
Art Center, Minneapolis, Minnesota;
Centre National des Arts Plastiques,
Paris
Production stills

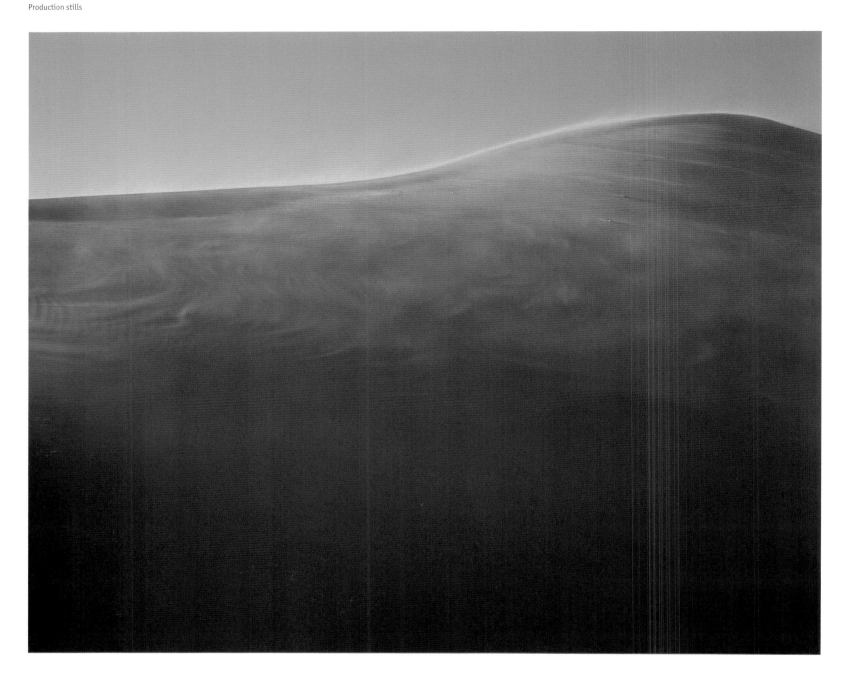

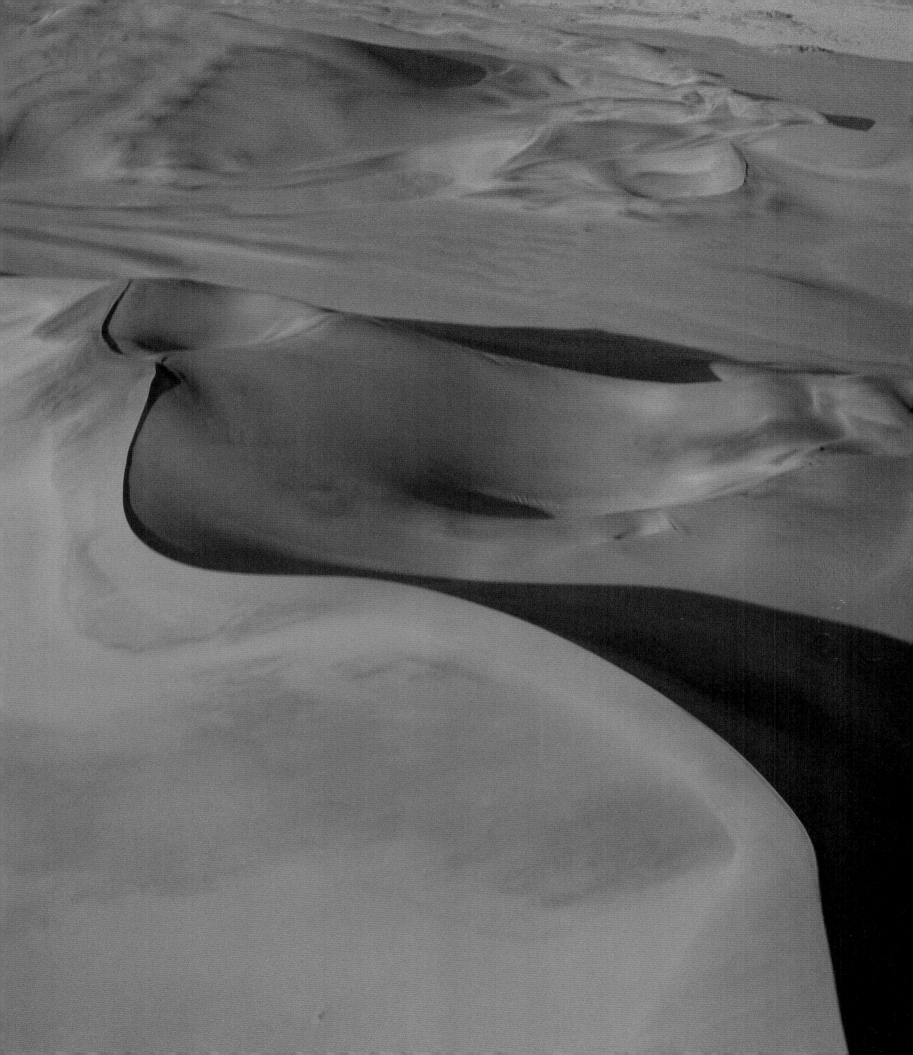

cathouse
1997
Colour film transferred to 3
channel digital video, sound and
architectural environment
2 min. cycle
Installation, 303 Gallery, New
York
below, exterior view
opposite, interior views

came across this death drive, Thanatos, when investigating what he called repetition compulsion, i.e., the tendency of certain patients to return obsessively to the most traumatic and hurtful experiences. Death, Freud maintains, exists within life as a principle of repetition: a mechanical drive to return to their original state of inorganic matter that precedes all forms of organic life, biological as well as intellectual. The cycling without beginning or end of *diamond sea* can be read as a grandiose illustration of a return to the mechanical processes of the inorganic produced through mankind's most advanced technologies. Through the implementation of rational calculation in combination with a limitless will to power, life in its most advanced forms turns against itself to produce a metallic environment of death. A bleak and distant moon over the empty desert is the sole witness to this infinitely circular story about diamonds, greed and sublime machines.

If *diamond sea* is a work about exteriority and the vastness of the landscape, the very opposite is true of the installation *cathouse* (1997), in which three people – a man, a woman and a twelve-year-old child – inhabit a rather claustrophobic architectural space. Shown on three separate monitors installed in a plywood structure that looks, indeed, like a large cat house, the piece is about emotional tension and the kind of pressure that builds up through repetitive actions. Although there is no dialogue or actual communication between the three people – whom the viewer is led almost inevitably to see as a paradigmatic Oedipal family unit – one can't help but experience the situation as a increasingly painful, even

unbearable, psychological predicament. Each character repeats a few basic actions. The man (played by Iggy Pop) is looking out of the window, staring into infinity. His fingers scratch a wooden chair. The camera's perspective gets increasingly narrow until all that we see are his fingernails scratching the wood. The boy walks into the bathroom; the light is cool and blue. It is afternoon. He looks into the mirror and begins to brush his teeth – an ordinary, repetitive kind of action, but this boy just won't stop. First it's hypnotic, but very quickly it becomes disturbing: he may not be able to stop. 'A drama caught in a loop',[11] is how the artist has described *cathouse*, with its traumatic atmosphere of repetitious, even monotonous scenes. The plywood structure in which the monitors are installed is completely clad in carpeting. Even if this cat house is not a strictly speaking cage, the claustrophobia produced reminds me of the unbearably repetitious meditations of Samuel Beckett's plays, for example *Unnamable* (1965): ' ... *I'm something quite different, a quite different thing, a wordless thing in an empty space, a hard shut dry cold black place, where nothing stirs, nothing speaks, and that I listen, and that I seek, like a caged beast born of caged beasts born of, caged beasts born in a cage and dead in a cage, born and then dead, born in a cage and then dead in a cage, in a word like a beast* ... '[12] There is something soothing and even soporific about monotony; it is the principle not only of lullabies but also of certain hypnosis techniques. Soon however, the repetition becomes increasingly irritating, and eventually unbearable. The overwhelming sensation from *cathouse* is of

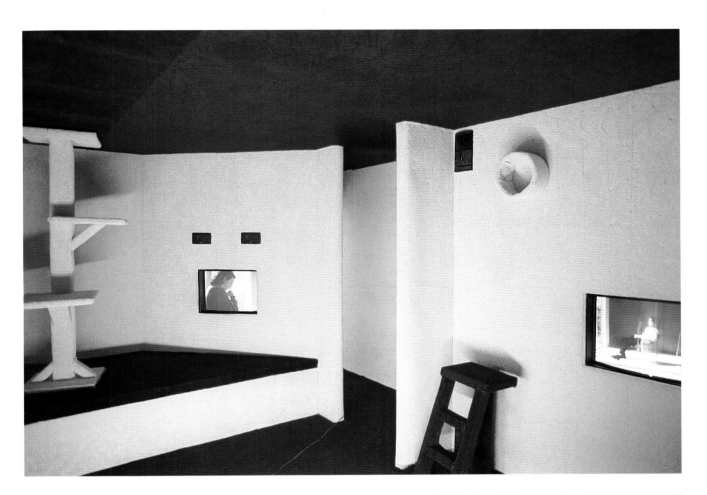

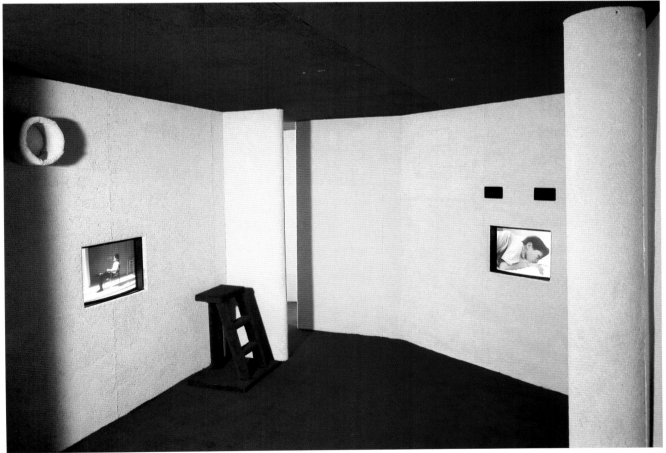

cathouse
1997
Colour film transferred to 3
channel digital video, sound and
architectural environment
2 min. cycle
Production stills

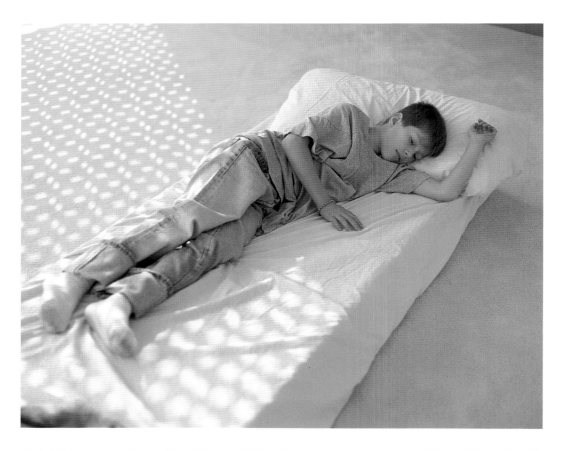

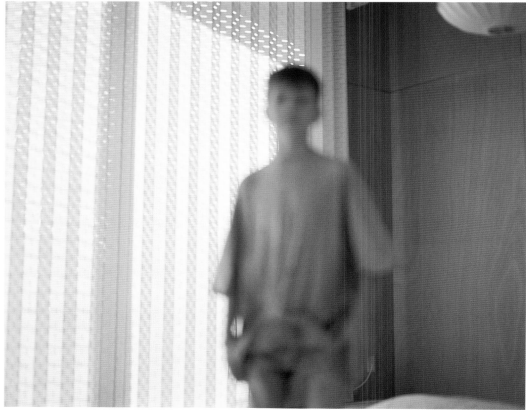

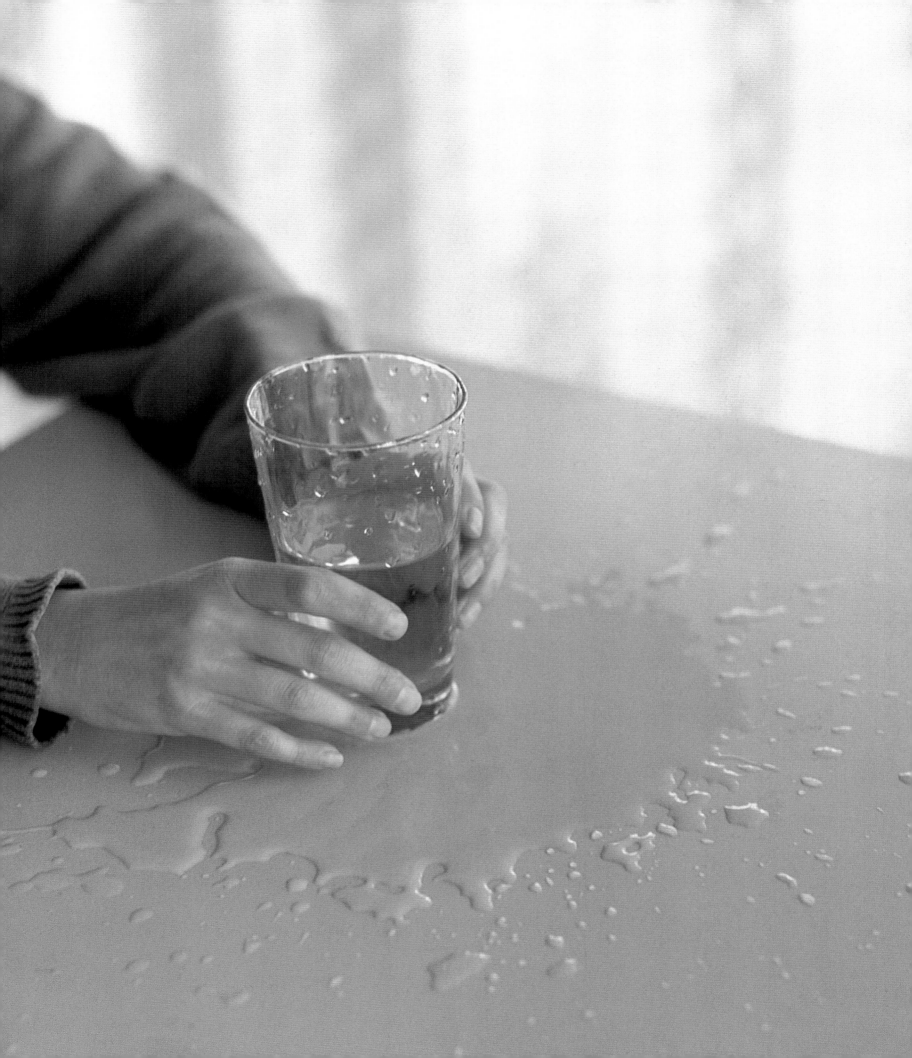

cathouse
1997
Colour film transferred to 3
channel digital video, sound and
architectural environment
2 min. cycle
Production still

being trapped in a revolving prison.

Humans are almost entirely absent from *diamond sea* but the passage of a human body through fully automated surroundings is the theme of another somewhat related work, the impressive eight-screen installation *electric earth*, which starts with what was absent in Aitken's earlier work: the gaze of a human eye. The protagonist, played by Ali Johnson, lies prostrate on a bed, the remote control in hand, gazing at a TV airing nothing but distortion. The eyes, the remote control and the monitor seem to define his confined universe. His drowsy stare expresses nothing but boredom and low energy; it is as dead as the flickering monitor. He mutters, '*A lot of times I dance so fast that I become what's around me. It's like food for me. I, like, absorb that energy, absorb the information. It's like I eat it. That's the only now I get.*' Is he an inmate in an electronically controlled cell, or a guest in some desolate motel room? It would appear the latter, because the next thing we know he is off on a night-time stroll, repeating over and over again the last phrase as a secret mantra: 'that's the only now I get, that's the only now I get'. Gone is the fatigue of the motel room; now begins his high energy trek across electric earth, an urban environment as devoid of humans as the automated desert in *diamond sea*. He is alone. He passes the airport at sunrise, his hands mimicking the rotation of the huge satellite dish. Night suddenly returns, as if time decided to rewind just before daybreak, and he walks the deserted streets of an empty shopping area, passing a closed supermarket and a trophy shop. His walk, increasingly mechanical and spasmodic,

develops into a bizarre dance that seems to conform to its surroundings in a continuous attempt to copy the syncopated rhythms and movements of the automated environment. 'A lot of times I dance so fast that I become what's around me.' He keeps to his initial declaration; this is a night of magical automatons.

Or is it the other way around? Maybe it is the electric paroxysms of this dancing wizard that animate the inorganic surroundings. At times it seems that it is his dance that sets the objects in motion. Car windows roll up and down mysteriously; a car wash comes alive; a shopping trolley in a deserted parking lot suddenly fills with spasmodic energy. He stands in front of a Coke machine trying to insert his dollar bill, but the machine spits it out again, then pulls it back, producing an epileptic fit that seems to spread from the machine to his body. There is no longer a sharp dividing line between organic body and machine. The automatic movements of a surveillance camera mimic the nocturnal wanderer – or is it vice versa? All the mechanical noises produce rhythms for dancing. The spasms in front of the Coke machine escalate into an ecstatic dance, the lonesome dancer breathing more and more heavily as the music turns into abstract drum and bass accompanied by the pulse of city lights. Aitken: '*The landscape in* electric earth *is stark and automated, but the electricity driving the machines is ultimately more important than the devices it drives. It's what the protagonist responds to, and, in turn, what puts him in motion.*' This electricity, which seems to pass through the environment as well as through the protagonist's body, does not

electric earth
1999
Colour film transferred to 8
channel laserdisc installation,
colour, sound
9 min. 50 sec. cycle
Collection, Museum of
Contemporary Art, Los Angeles;
Whitney Museum of American Art,
New York; Fondazione Sandretto
Re Rebaudengo per l'Arte, Turin
following pages, installation, 48th
Venice Biennale
pages 64–65, video stills

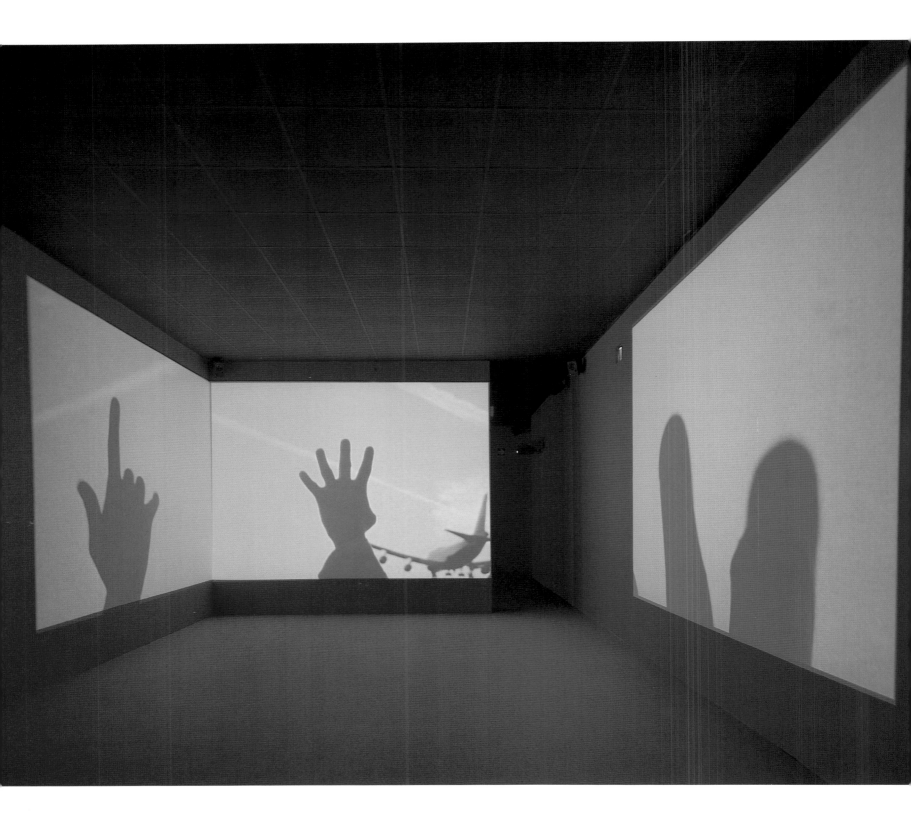

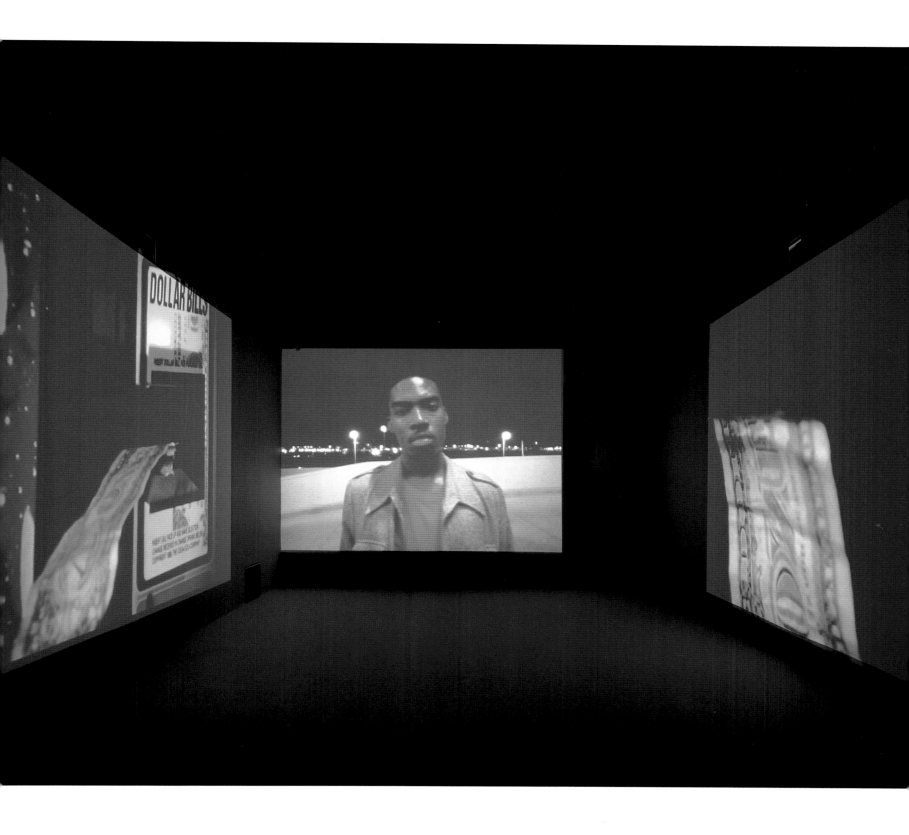

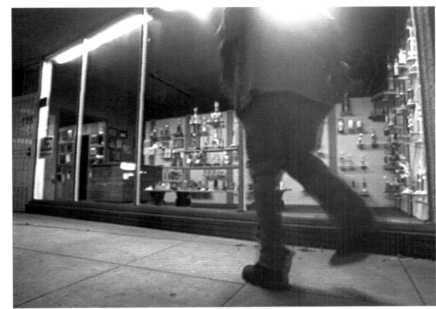
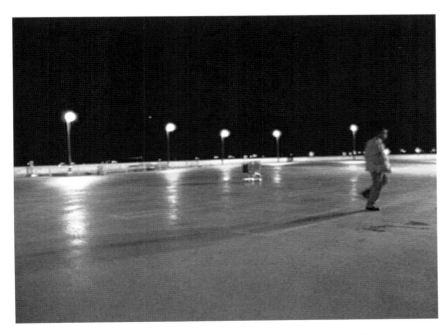
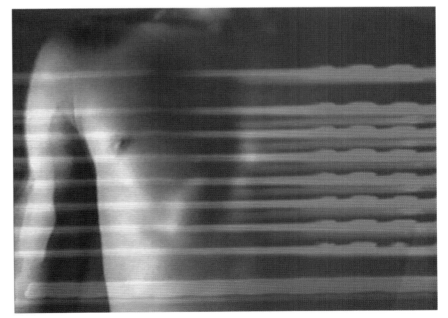

electric earth
1999
Colour film transferred to 8
channel laserdisc installation,
colour, sound
9 min. 50 sec. cycle
Collection, Museum of
Contemporary Art, Los Angeles;
Whitney Museum of American Art,
New York; Fondazione Sandretto
Re Rebaudengo per l'Arte, Turin
Installation, 48th Venice Biennale

distinguish between organic and inorganic, between natural and artificial.

This vision clearly represents a break with the traditional organism/artefact distinction, and seems closer to the view that everything is machine-like, a notion that can be found in the seventeenth-century cosmology of philosopher G. W. Leibniz. In his *Monadology* (1714), he states: '*Every organic body of a living being is a kind of divine machine or natural automaton, which infinitely surpasses any artificial automaton, because a manmade machine is not a machine in every one of its parts ... But nature's machines – living bodies, that is – are machines even in their smallest parts, right down to infinity.*'[13] Thus, there is no difference of kind between a living body and a mechanical device. In Leibniz's Baroque cosmos, organic substances are no different from inorganic ones; as interpreted by Deleuze, 'Whether organic or inorganic, matter is all one.'[14] In *electric earth*, the automatic paroxysm of the inorganic

environment seems to communicate intimately with the paroxysms of the protagonist's bodily parts. Yet there is a major difference between their visions: the Baroque philosopher's universe is one of stability and harmonious co-operation between all parts; Aitken's apocalyptic Baroque is one of dysfunctional friction and collapse. The systems of communication are no longer operative. Things don't work, they only display the mechanical spasms and automatic convulsions typical of devices on the verge of total breakdown.

So what is the hyperkinetic stroll in *electric earth* really about? Aitken expounds, '*It's structured around a single individual, whom I imagined as being the last person on earth. He is in a state somewhere between consciousness and unconsciousness, and he is travelling through a seemingly banal urban environment in the moments before nightfall. As he moves, the world around him – a satellite dish, a trash bag spinning in the air, a blinking streetlight, a car window – begins to accelerate.*'[15] Is this a gloomy vision of the future, showing the last human in a world populated only by machines, the last man himself on the verge of final mechanization? Such an interpretation would be in line with the understanding of *diamond sea* as a grandiose scenario showing the *danse macabre* of death machines, but Aitken's narratives can never be pinned down in such a singular way. They are open-ended and circular. What does seem clear, though, is that the predicament displayed in *electric earth* is that of a human body that can no longer be described in the terms of traditional humanism or phenomenology: the human as a reflecting being in control of its own actions and

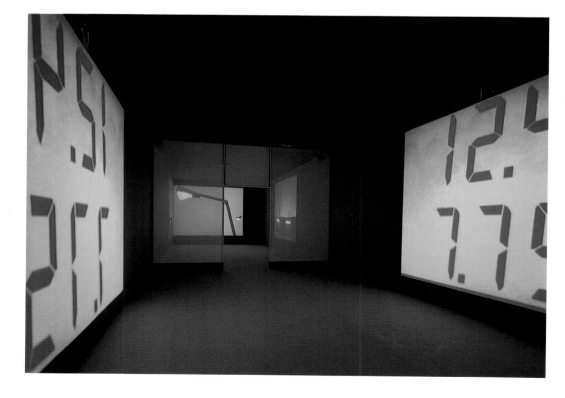

thoughts and enjoying a harmonious relation to its own body. The rhythmically advanced cybernetic machine in *electric earth* is an amazing performer, but the dance is not one of serene self-awareness, it is rather one of technological disturbance and crisis. The phenomenological subject has always been described as existing in the immediacy of the Now. Yet Aitken's protagonist has clearly lost this sense of the now; instead he is in a state of continuous flux with a different experience of time: 'That's the only now I get.'

With regard to this nocturnal high-tech stroll, the artist has described the experience in temporal terms: '*Taking a walk can be an uncanny experience. Propelled by our legs we find rhythms and tempos. Our bodies move in cycles that are repetitious and machine-like. We lose track of our thoughts. Time can slip away from us; it can stretch out or become condensed. But this loss of self-presence, it seems, can sometimes produce another kind of time, the speed of our environment becomes out of sync with our perception of it. When this happens, it creates a kind of grey zone, a state of temporal flux. The protagonist in* electric earth *is in this state of perpetual transformation. The paradox is that it also creates a perpetual present that consumes him.*'[16] This perpetual present, 'the only *now* he gets', is not a simple temporal atom but rather the effect of complex systems of communication and of technological detours. The subject − if that term can still be applied − is no longer characterized by unity and oneness. Instead it appears as part of a network of flows and pulses, open-ended and unpredictable. Its sense of a *now* arises when the present merges with its technological surrounding

and becomes part of the all-encompassing place known as 'electric earth'. From the phenomenological perspective, the lived body represents the absolute 'here and now' of experience, the firm ground around which everything else revolves. The situation that Aitken describes in *electric earth* clearly puts this into question; it would seem that the construction of subjectivity through new technologies and the media cuts right to the very bodily core of human identity.

In several works he explores the powerful machinery of the media and the entertainment industry. *bad animal* (1996) and *into the sun* (1999), for example, both examine the film industry, yet from diametrically opposed perspectives. *bad animal* exhibits the pathetic delusions of an individual, a person crashing at full speed into the merciless wall hidden behind the Hollywood fantasy; whereas *into the sun* presents the Bollywood dream-machine at work, its wheels spinning faster and faster until the whole apparatus seems almost to collapse. *into the sun*, shot in Mambai (formerly Bombay), India, is a three-screen video installation about the acceleration of fame and the mass-proliferation of moving images. '*Speed is at the core of the Bombay filmmaking machine*', explains Aitken in a written statement about *into the sun*.[17] '*The style and technique used in creating* into the sun *will implode the subject of motion pictures in on itself. This is not a documentary; it is a work which explores the mechanism of accelerated media in a sensory, experiential and conceptual manner.*'[18] The dominant hue of the piece is one of hot yellow sand, fire and orange-tinted Indian sunshine.

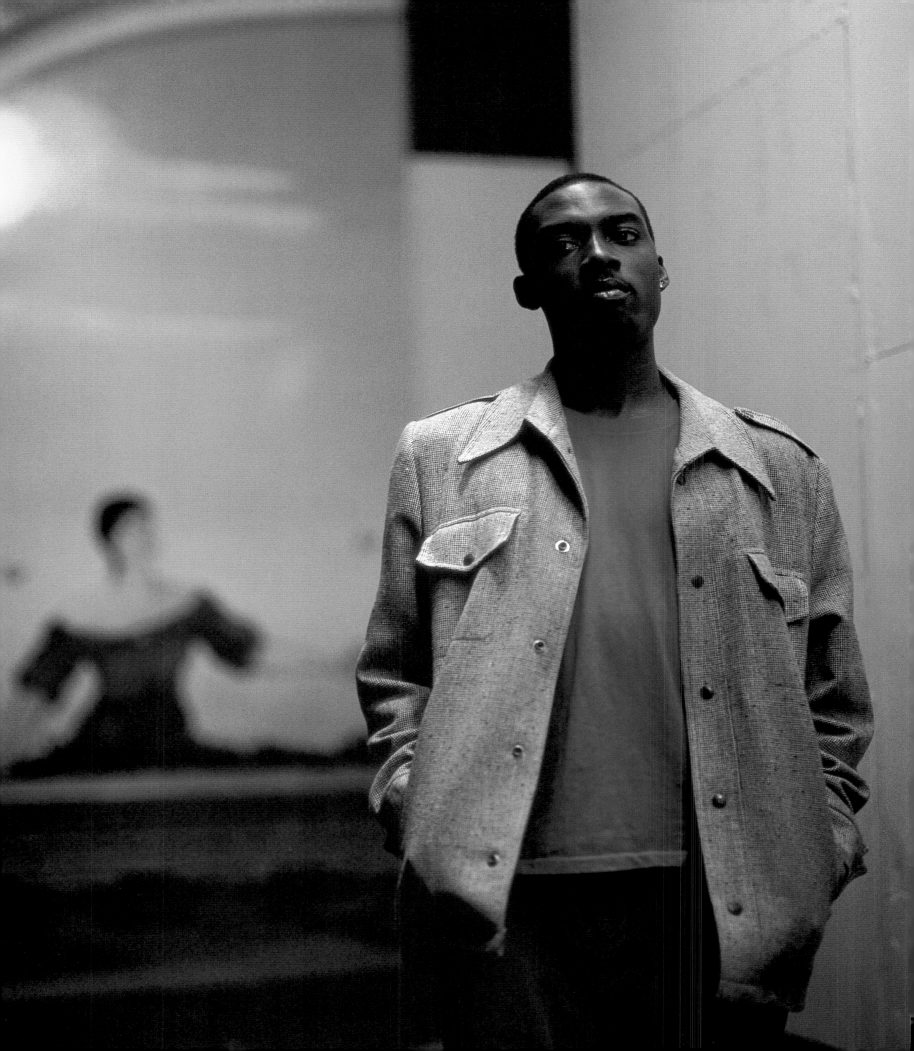

electric earth
1999
Colour film transferred to 8
channel laserdisc installation,
colour, sound
9 min. 50 sec. cycle
Collection, Museum of
Contemporary Art, Los Angeles;
Whitney Museum of American Art,
New York; Fondazione Sandretto
Re Rebaudengo per l'Arte, Turin
Production stills

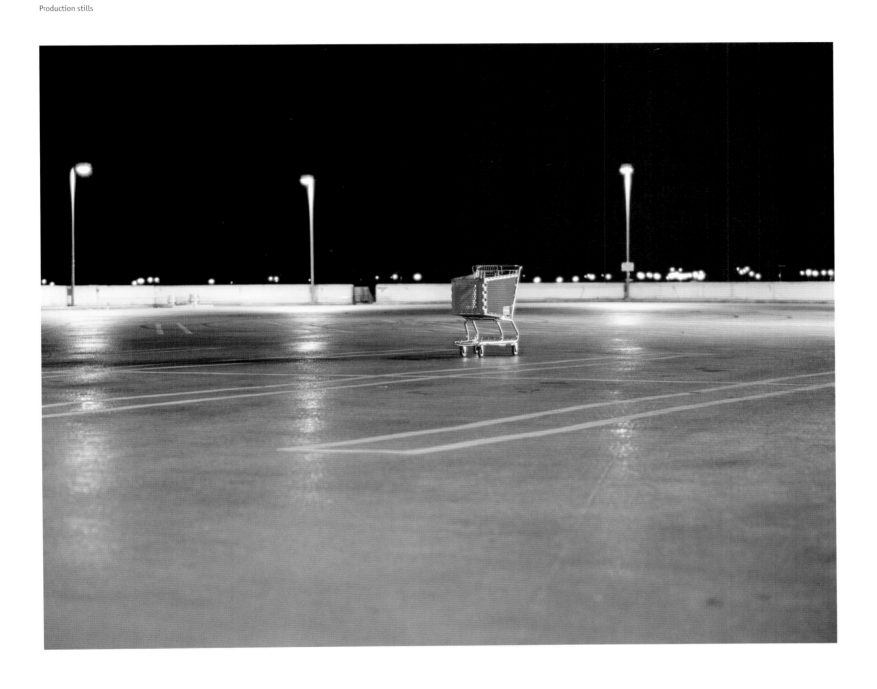

bad animal
1996
Colour film transferred to 3
channel digital video, sound and
architectural environment
9 min. cycle
Collection, Fondazione Sandretto
Re Rebaudengo per l'Arte, Turin
Video stills

following pages, **glass horizon**
(exterior)
2000
Colour film transferred to
projected digital video
Installation, Wiener Secession,
Vienna

Fragments of film interwoven with stills show various moments in the Indian film industry: fragments of actual performances; production sites; billboards advertising the actors' studio equipment; the film camera; the strip running on the spool; spotlights and film reels in silver boxes stacked in huge piles; the facades and interiors of the cinemas; crowds of fans. And of course the stars themselves, in action or backstage; close-ups of an eye or a mouth; a printer spitting out their posters at a quickening pace. We see a bird flying in a burning hot sky. The wheels of the whole machine turn faster and faster as the temperature rises. The sound of the reel spinning on the projector is followed by sitar strings and the noise of the printer. The celebrity machine accelerates, intent on spitting out fictitious identities blown out of proportion. '*While in Western media culture, a celebrity plays a role but is still seen as human and fallible, it is only in Indian cinema that actors can step through the door of the mythological, literally*

to become the roles they play. The division between real time and reel time is not blurred; it is nonexistent.'[19] The Indian film superstar Aamir Kahan appears on the set and a crowd gathers, everybody is eager to get a view of this deity: '*Clusters of people stand on top of cars; crowds look down from the tops of high-rise buildings. A strange tension is felt, the desire to get as close to Aamir as possible, to touch him, to see if he is, in fact, human while at the same time give him sacred respect and the distance as he has flown into the sun.*'[20] Escalation, acceleration, intensification. The camera zooms in on faces and details, faster and faster. The final collapse, it seems, must come at any second.

bad animal, on the other hand, is about the single individual longing to become part of this machine, but allowed only to enter his own fantasies. When looking down at Los Angeles from an aeroplane, the protagonist dreams: 'I realized that Hollywood smelled like me. I knew then that I

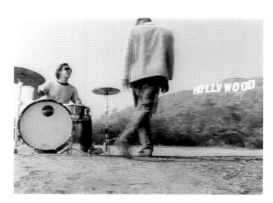

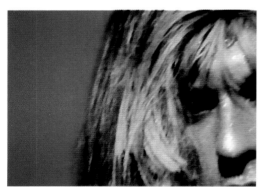
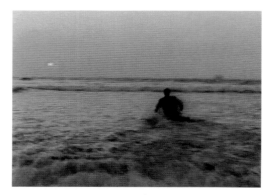

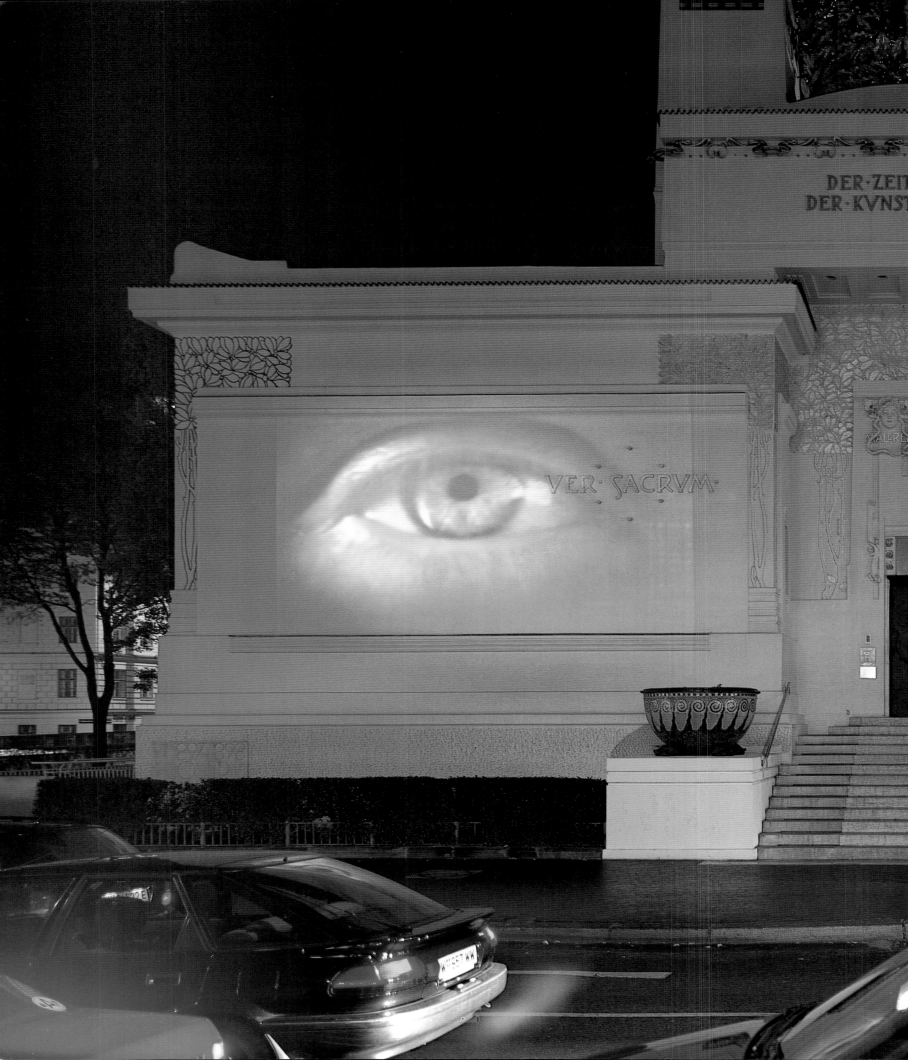

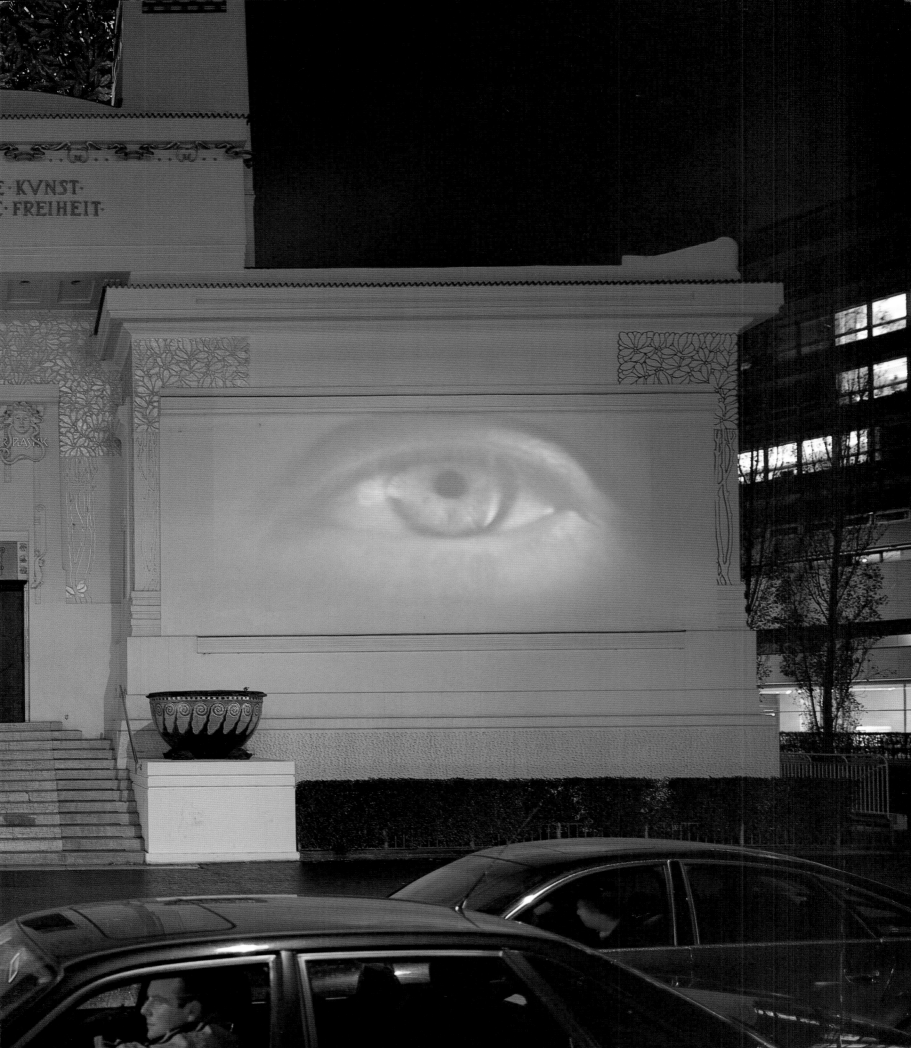

Andy Warhol
Green Disaster Ten Times
1963
Silkscreen ink on synthetic
polymer paint on canvas
267.5 × 201 cm

was destined to become a star.' We follow the pathetic itinerary of a wannabe whose sense of self vacillates between megalomania and self-destruction. 'Sometimes it's so difficult to navigate by the stars', he comments while stumbling along the Hollywood Walk of Fame. 'The hard beat of this place is hard to dance to', he realizes before cutting the letters WOW into his chest, emptying a bottle of booze and disappearing into the Pacific Ocean at sunset. If *into the sun* is about the production of celebrity, *bad animal* is about the deplorable clichés and all-too-human remains left behind by the relentless dream-machine. In both of these works identity comes forth as a construction, as an effect of other structures, in this case the media and entertainment industries. The influence of the media on our perception of the world and ourselves is explored in several works, some of which consist solely of film citations and television clips, like *i'd die for you* (1993), *dawn* (1993) and *hysteria* (1998). In *i'd die for you*, shot on video, Aitken offers up fourteen deaths, all appropriated from John Wayne movies, from *Dark Command* (1940) to *The Shootist* (1976). In each of these excerpts, Wayne is killed: burned alive, drowned, beaten to death, or simply shot. The footage is slowed down and accompanied by a discrete soundtrack recorded by Aitken at Wayne's final resting place at Ocean View Memorial Park in Newport Beach, California. If death is the ultimate moment of truth, that unique instant when the self is forced to reflect upon its own being, then these mass-produced Hollywood deaths represent the most radical of simulacra. Like Andy Warhol's *Disasters*, Aitken's *i'd die for you* interrogates the

idea of human uniqueness at its very root: if even our experience of death is based on Hollywood clichés, then life is a construction through and through.

In *Dawn*, Aitken has produced a different kind of collage of clips, not about death but about adolescence. The excerpts are from four different psychodramas about white American suburban youth becoming acquainted with the adult world, an engagement that produces not only anxiety but defiance. No doubt such films, produced for television and watched by millions, gives expression to what it means to be young in the US. '*What becomes clear at looking at this work*', writes critic Douglas Fogle, '*is that Aitken sees the media not as the entity Adorno derisively called "the culture industry", but as just another landscape to traverse neither uncritically nor dogmatically*'.[21] This is certainly true of *hysteria*, which documents thirty-five years of collective rapture at rock concerts, from the rather harmless Beatlemania of shrieking girls, to more violent forms of group dynamics. Besides being an exploration of different stages in the recent history of the performer/audience dialectic, wherein the audience shifts through various phases of participation, Aitken's video also renders the movements of the crowd in an interestingly detached manner. We get close-ups of individuals: an ecstatic face; a bare-breasted girl dancing; a guy drinking bourbon straight from the bottle. Then the individual is no longer discernible; the crowd appears as something rather abstract: a billowing sea of waving hands and bodies moving in unison, like a slowly undulating landscape.

hysteria (breaths)
2001
Sound and architectural
environment
Installation, 'Metallic Sleep',
Kunstmuseum, Wolfsburg

The media landscape pertinent to Aitken's work is by no means limited to imagery, but is as much a matter of sound. In fact, the very audio/visual distinction barely seems relevant: both can be broken down to digital data to be sampled and manipulated in unlimited ways. Having worked as a director of music videos for, among others, Fatboy Slim and Iggy Pop, Aitken is conscious of the power of the soundtrack, and that sound and vision are equally important to the experience of his work. Aitken explains: '*I created a kind of digital library of field recordings and then took these sounds back and created a composition. By looping, sampling and stretching them out, I created an original composition that went with the installation. A situation like that reflects my approach: the sound has to be intrinsic to the work – both specific and accurate at once.*'[22] The sound design – frequently ambient music and compilations of site-specific recordings – often adds a melancholic atmosphere to Aitken's works. He talks about the successful co-operation of sound and vision in his pieces as a kind of alchemy.[23] On a few occasions, he has chosen to work only with sound; for 'Art in the Anchorage' (Brooklyn, New York, 1996), nothing visual was added to the architecturally powerful site. Instead, the acoustics of the space and the sound of the traffic on the bridge above were taken as the point of departure for a purely auditory work of art.

A piece that brings together Aitken's interest in sound with that of the American landscape, technological environments, and the concept of speed, in this case the speed of speech, is *these restless minds* (1998). Displayed on three monitors

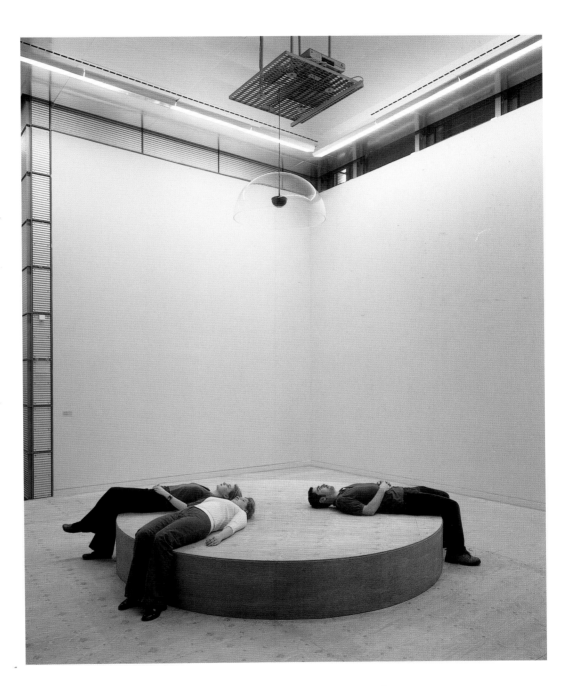

i'd die for you
1993
single channel colour and black
and white video of appropriated
film, video and sound
10 min. cycle
Video stills

i'd die for you
1993
single channel colour and black
and white video of appropriated
film, video and sound
10 min. cycle
Video stills

hysteria
1998–2000
Colour and black and white video
of appropriated film, video and
sound, 2 channels, 4 projections,
architectural environment
6 min. 15 sec. cycle
Collection, FRAC Haute
Normandie, Sotteville les Rouen,
France
right and following pages,
installation, 'Glass Horizon',
Wiener Secession, Vienna, 2000
opposite, video stills

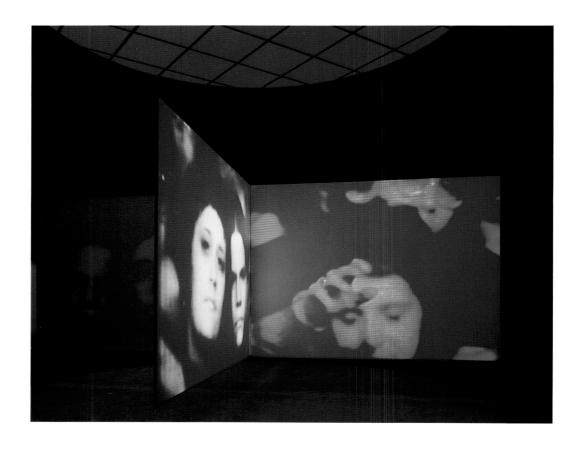

attached to a ring that hangs from the ceiling, this work shows a group of small town auctioneers who normally sell cattle or used cars. In Aitken's work, they perform endless litanies describing their immediate surroundings, almost freeing the voice from its human origins. The mouth becomes a kind of machine; the speed of calling and chattering suggesting religious ecstasy rather than business transactions. The images of the auctioneers, seemingly speaking in tongues, are contrasted with familiar shots of the American landscape:

night traffic, rotating radar antennae, a swimming pool. The landscape, seen from a moving car, accelerates; the voice increases in speed and leaves language behind, shifting into abstraction. It no longer signifies. Such a transition, from the familiar to the abstract, has many visual counterparts in Aitken's works.

An eye that never blinks is an eye that is constantly exposed to infinity. When German Romantic writer Heinrich von Kleist first saw Caspar David Friedrich's painting *Monk by the Sea*

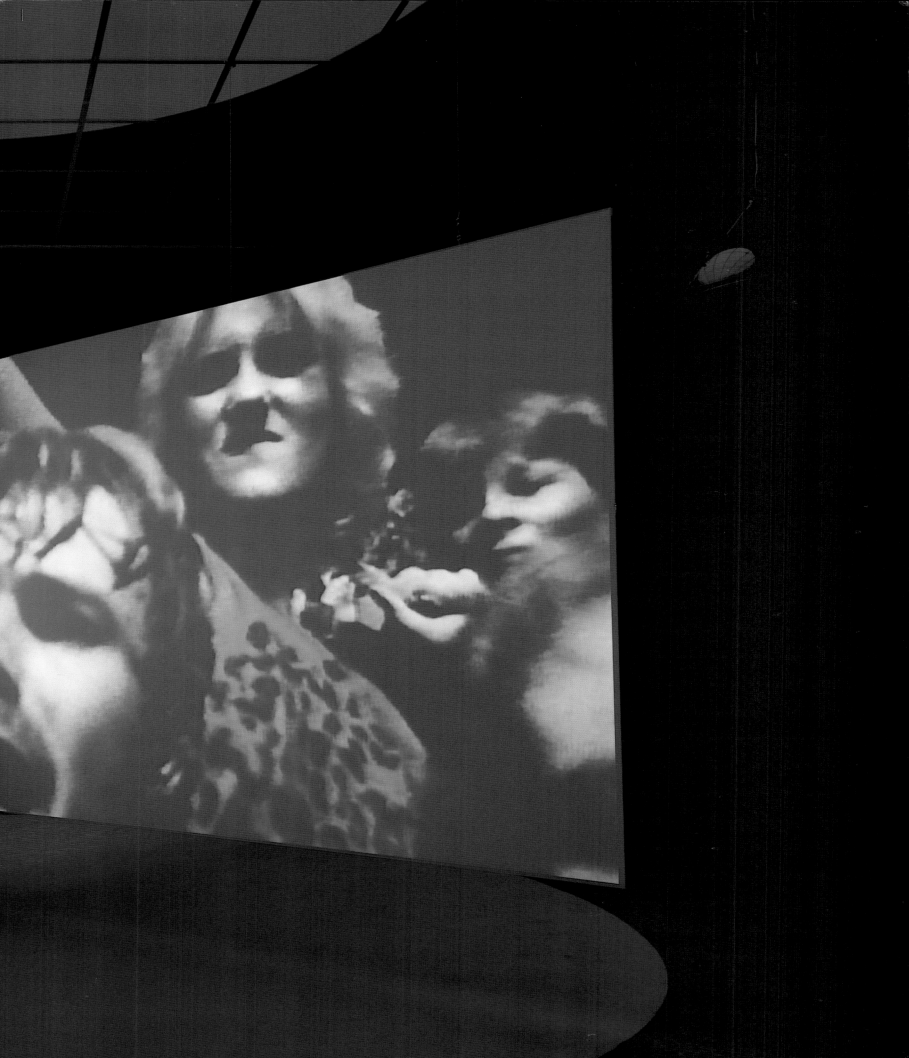

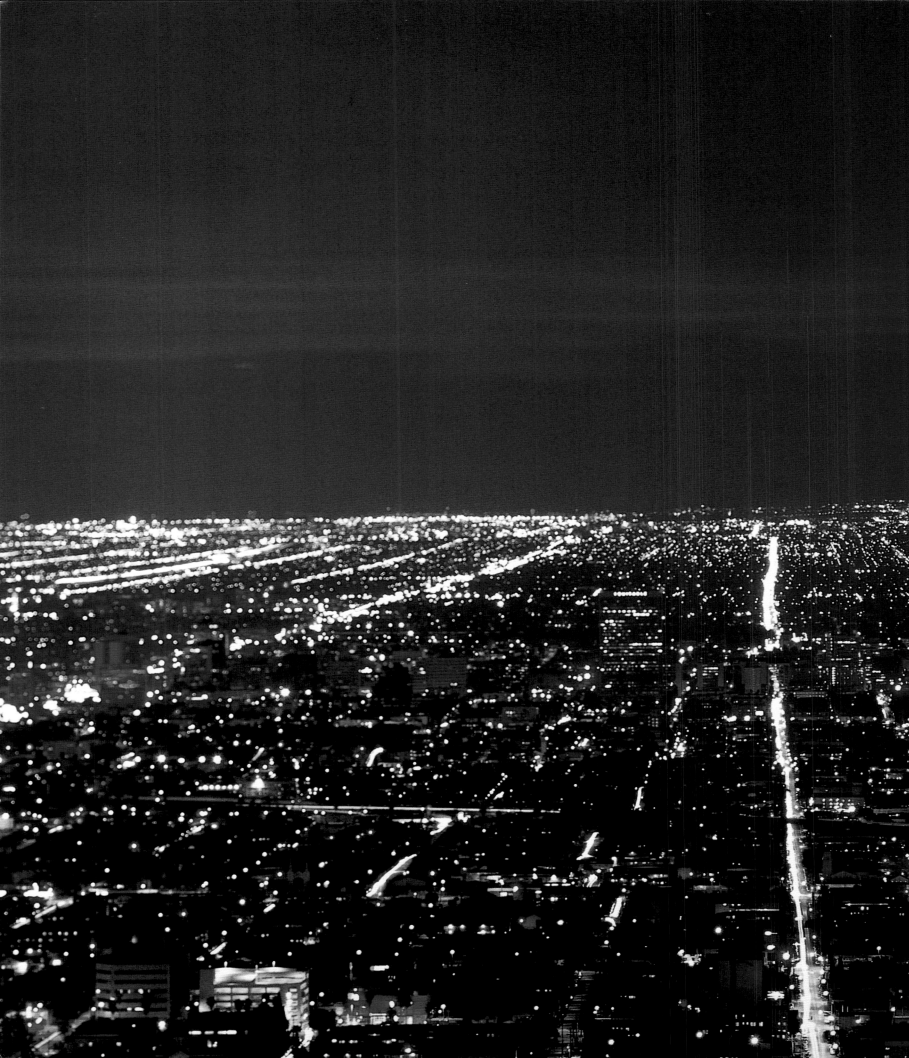

rise
1998
C-print mounted on Plexiglas
76 × 89 cm
Collection, Walker Art Centre,
Minneapolis, Minnesota
also **rise**
1998/2001
Fujitran print in aluminium
lightbox
228.5 × 335.3 × 45.5 cm

moving (with Jon Huck)
1997
Audio compact disc, 4 runway
lights, programmed sync box
Dimensions variable
Installation, 303 Gallery, New
York

lights of Los Angeles and the blue infinity of the Pacific, also verges on abstraction, and comparable moments can be found in almost all of Aitken's video works. When the rocket turns upside down in *inflection*, an instant of pure whiteness precedes the downward journey; in *electric earth* moments of television distortion introduce grainy intervals of greyness. The landscape – whether it be Namibia, Guyana or the suburbs of Los Angeles – plays a central role in most of the works, but it's never a question of a pure natural landscape, untainted by culture and technology. On the contrary, today's artificially altered sense of nature has rarely been captured with such precision as in Aitken's videos, not only when the landscape has given way to the mediascape of Los Angeles, but in those works where the cultural traces are more delicate.

monsoon (1995) was shot in Jonestown, Guyana, where in 1978 the followers of Reverend Jim Jones committed mass suicide. *monsoon* offers fragments of a village that has been repossessed by the jungle; birds and crickets provide the soundtrack. The camera zooms in delicately on small details – a red flower, parts of an old tractor, ants scurrying along a crack in the dry earth – and seems to make no distinction between nature and artefact. Then we get the larger view: dark clouds, a storm arriving. The footage offers nothing but the anticipation of a monsoon. That was the artist's only preconception of the piece: he would go to the site of the tragedy without a shooting script and stay until a monsoon arrived. One hopes for a storm that can wash way all the remnants of the past, finally deleting all traces of the sad sect.

(1809), showing a solitary human being in front of the open sea, he compared the experience with getting one's eyelids removed. This is landscape painting on the verge of abstraction. If a few details were removed, the dramatic encounter of sky and sea could just as well be seen as a non-figurative image, like a painting by Mark Rothko.[24] Aitken's production still *rise* (1996), showing the

left and following pages,
monsoon
1995
Colour film transferred to single
channel digital video, sound
6 min. cycle
Production stills

85 **Survey**

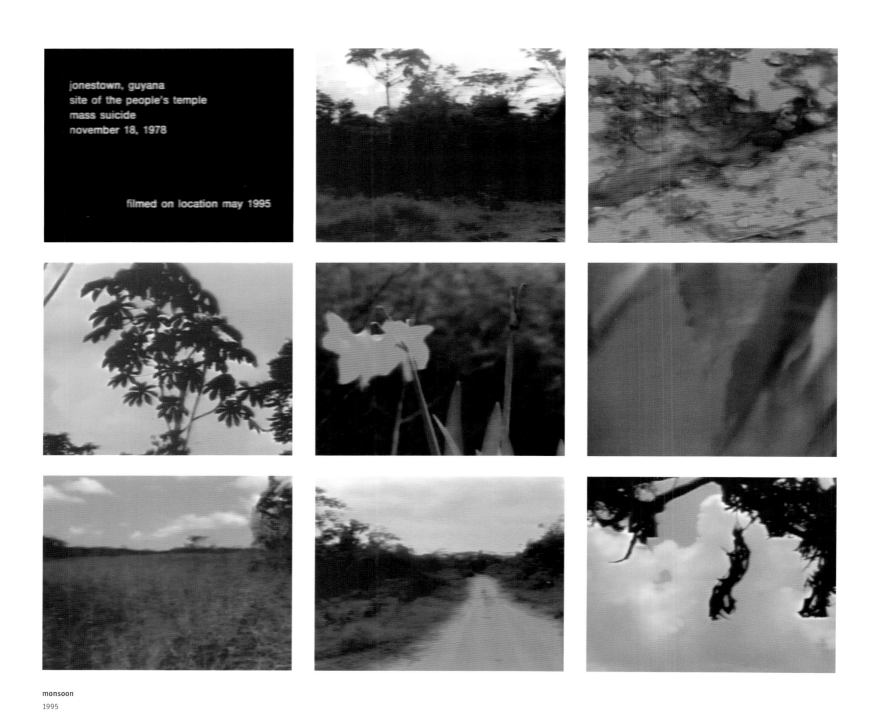

jonestown, guyana
site of the people's temple
mass suicide
november 18, 1978

filmed on location may 1995

monsoon
1995
Colour film transferred to single
channel digital video, sound
6 min. cycle
Video stills

The strain increases every second, but the rain never comes. Momentary images of still beauty – a green bush against the clear sky, the patterns of leaves against the blue – give us solace, but the tension builds. As viewers we are caught in the unnerving interval between the memory of pain and a future that never arrives. '*I was interested in inaction, or waiting*', says Aitken. '*Waiting in this location for as long as it takes for a monsoon to hit. In the end, the emphasis became more on the subtleties that we found: this is what ultimately created the narrative.*'[25] When the rain seems to be coming close, the work is suddenly over.

The understanding of landscape as a complex conglomerate of disparate elements was clearly formulated in artist Robert Smithson's projects. In 'Proposal' (1972), he contended: '*The visual values of the landscape have been traditionally the domain of those concerned with the arts. Yet art, ecology and industry as they exist today are for the most part abstracted from the physical realities of specific landscapes or sites. How we view the world has in the past been conditioned by painting and writing. Today, movies, photography and television condition our perceptions and social behaviour.*'[26] The list of relevant visual technologies has since been added to, yet in many ways one can see Aitken's interest in the contemporary landscape as a continuation of Smithson's meditation upon nature, art and abstraction. Aitken's automated milieu and the abstract, sometimes monochromatic, qualities he finds in the landscape are also reminiscent of Smithson's observation in 'Nature and Abstraction': 'There is no escaping nature through abstract representation; abstraction brings one

closer to physical structures within nature itself.'[27]

Independently of the large and time-demanding video installations, Aitken has consistently produced still photographs that have been presented in exhibitions and in the form of artist's books, such as *metallic sleep* (1998), *diamond sea* (1998), and most recently, *I Am a Bullet* (2000), the latter a close collaboration with writer Dean Kuipers. *I Am a Bullet* explores new and sometimes extreme forms of life in distant parts of the world (Japan, India, the United States), and is also a celebration of acceleration and speed: '*Acceleration is no longer an intangible function of the imagination, gently nudging the ordinary events that constitute history. Right now acceleration is history. It is the event. Acceleration is the prime physical, technological and even spiritual engine of the moment ...* '[28] The photograph, always a frozen moment, can depict objects in motion, but remains incapable of capturing motion and time themselves, much less new forms of technological acceleration.

Aitken's photographs of sky, land and sea in, say, *metallic sleep*, instead relates to a strong tradition in American art. The interest in the landscape as something transcendent or sublime is often associated with 1960s Californian artists such as James Turrell, but is an even older American tradition. Writing in the late 1940s about the uniqueness of the new American art which has freed itself of weighty European aesthetics and its cult of beauty, artist and theorist Barnett Newman phrased this newness in terms of the sublime. This sublime dimension, given expression in Newman's own abstract canvases, he associated with the

James Turrell
Roden Crater
1977–present
Excavation of crater and walkway
on volcanic moiuntain
Flagstaff, Arizona

Robert Smithson
Partially Buried Woodshed
1970
Kent, Ohio
Documentation photograph

Frederic Edwin Church
Morning in the Tropics
1877
Oil on canvas
138 × 214 cm

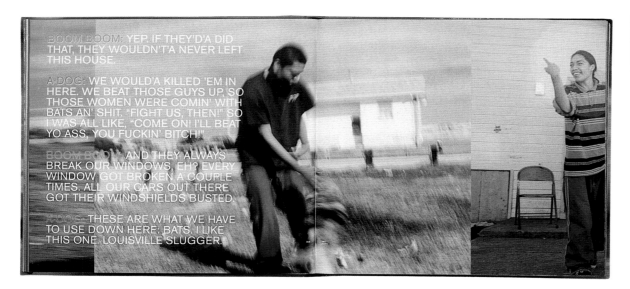

BOOM BOOM: YEP. IF THEY'D'A DID THAT, THEY WOULDN'T'A NEVER LEFT THIS HOUSE.

A-DOG: WE WOULD'A KILLED 'EM IN HERE. WE BEAT THOSE GUYS UP, SO THOSE WOMEN WERE COMIN' WITH BATS AN' SHIT. "FIGHT US, THEN!" SO I WAS ALL LIKE, "COME ON! I'LL BEAT YO ASS, YOU FUCKIN' BITCH!"

BOOM BOOM: AND THEY ALWAYS BREAK OUR WINDOWS, EH? EVERY WINDOW GOT BROKEN A COUPLE TIMES. ALL OUR CARS OUT THERE GOT THEIR WINDSHIELDS BUSTED.

A-DOG: THESE ARE WHAT WE HAVE TO USE DOWN HERE: BATS. I LIKE THIS ONE. LOUISVILLE SLUGGER.

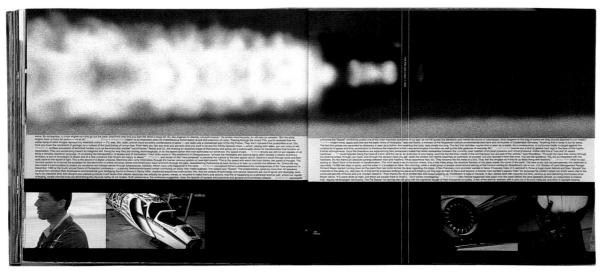

I Am a Bullet
1999
Artist's book
Published by Crown
Text by Dean Kuipers

American landscape and with the Indian mounds that he had seen in Ohio. If a history of the American sublime is to be traced via artists such as Newman, Smithson and Turrell (or long before, Frederic Edwin Church, 1826–1900) all the way up to Aitken's photographs and video installations, then one must keep in mind the altered sense of the experiencing subject. The sublime experience in the Romantic tradition was defined in Kantian terms as an experience of the subject's inner capacities to comprehend infinity. The vastness of a landscape, as depicted by, say, Caspar David Friedrich, was seen as a manifestation of the subject's inner struggles. The modern American subject of Newman's writings is equally heroic: the sublime American image mirrors modern man: 'Instead of making cathedrals out of Christ, man or "life", we are making them out of ourselves, out of our own feelings.'[29] In more recent artists such as Smithson and Turrell, the heroic subjectivity of Romanticism and Abstract Expressionism is no longer in place, but their artistic projects can none the less still be understood in terms of a phenomenology: in Turrell's case a

9 SPEED AS VEHICLE

3 SPEED were comming AS MEDIA

phenomenology of perception linking the eyes to kinaesthetic experience; in Smithson's case a more extreme archaeology of cultural sedimentation.

Aitken's world can no longer be understood in terms of a traditional phenomenology; his landscapes are not directed towards a subject. This becomes increasingly clear in his more recent installations where a multiplicity of perspectives coexist and where the 'brain', in Deleuze's words, 'has lost its Euclidean coordinates, and now emits other signs'.[30] These 'other signs' can no longer be linked to the unifying concept of a subject. In

works such as *electric earth* and *i am in you* (2000), the self is a zone where times and space intersect, and the very concept of experience must be thought of in terms of this plurality. *eraser* (1998) records the artist's trek across the Caribbean island of Montserrat a year after it was devastated by the eruption of a volcano. The artist followed a perfectly linear, seven-mile path from the north to the south, from coast to coast, recording the post-catastrophic landscape. The camera sees abandoned houses, a clock tower, an empty street, the interior of a chapel, a red telephone covered

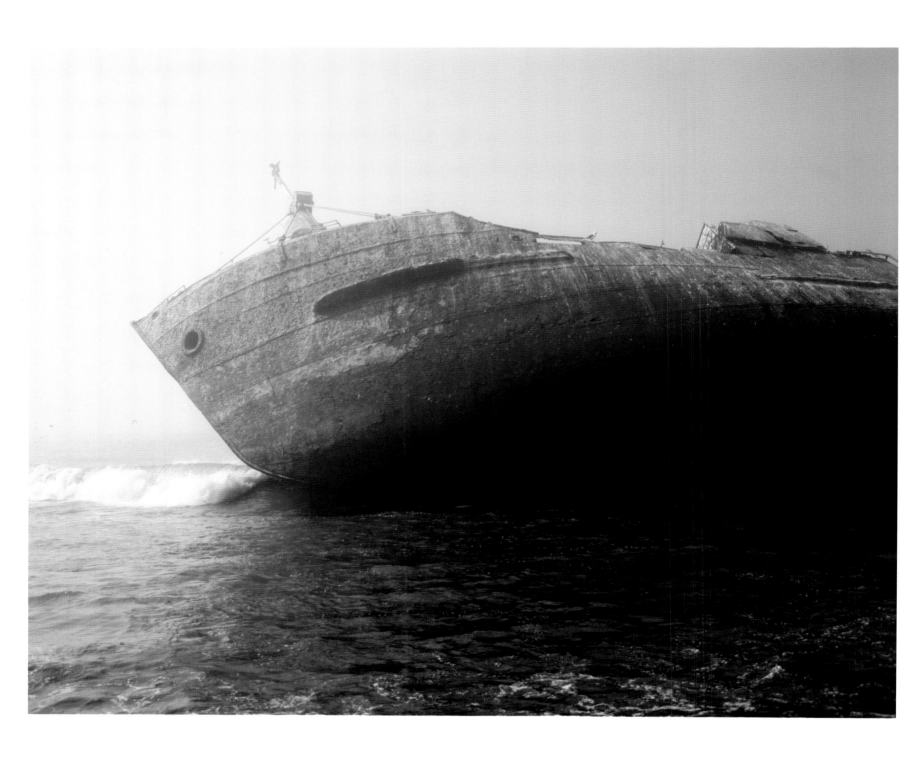

2 Second Separation
2000
C-prints mounted on Plexiglas
Diptych, 151 × 122.5 cm each

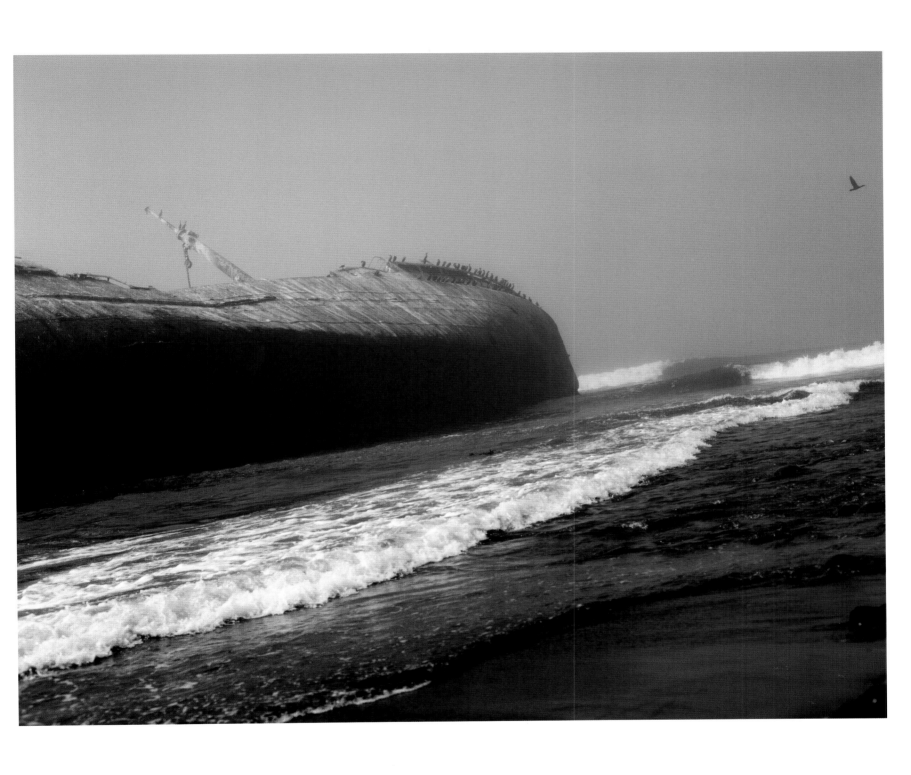

 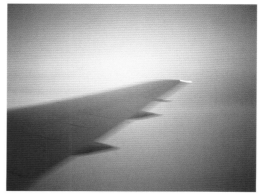 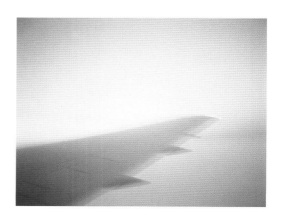

above, **Turbulence**
1999
C-prints mounted on Plexiglas
Triptych, 85 × 108.5 cm each

with sand. It zooms in on single objects and details: remains of the life that once flourished on the island. This journey through a wild and even hostile landscape is intensely melancholic. Dry, cracked earth; a wild forest; old industrial machinery: this is a journey into the past, through a world that no longer exists. Despite all the things encountered, absence is what is most strongly felt. The sound – a composition of fragments recorded on site, looped and stretched – intensifies the melancholic mood. The voice of Louis Armstrong from a radio playing for nobody fades away into the night.

The camerawork produces a sense of proximity and immersion. It is as if the viewer is winding a path through the jungle and searching out the shelter of a vacant building. *eraser* attempts to erase the distance between the viewer and the landscape, to involve the viewer to such an extent that the work becomes part of their stream of experience and vice versa. Putting such emphasis on the viewer could be seen as the ultimate phenomenology, and one could perhaps claim that

the complete immersion in *eraser* pushes the viewer's subjectivity to a point where the phenomenological model of experience breaks down. This more complex space allows for the participation of the viewer but also brings the viewer's unity and stability into question. In works such as *electric earth* and *into the sun,* the complexity not only has to do with the multiple projections, but also with the active involvement of viewers who decide their own pace when moving through the installations. Such kinaesthetic and perceptual multiplicity can no longer be thought of in terms of a harmonious experiencing subject. If the sublime landscape of the Romantic painter was understood as a manifestation of the subject's inner struggles, the protagonist in *electric earth* not only moves through the environment but seems to become part of the electrified landscape. He is a projection of the environment, rather than the other way around.[31]

'The concern with space bores me', wrote Barnett Newman. 'I insist on my experiences of sensations of time – not the *sense* of time but the

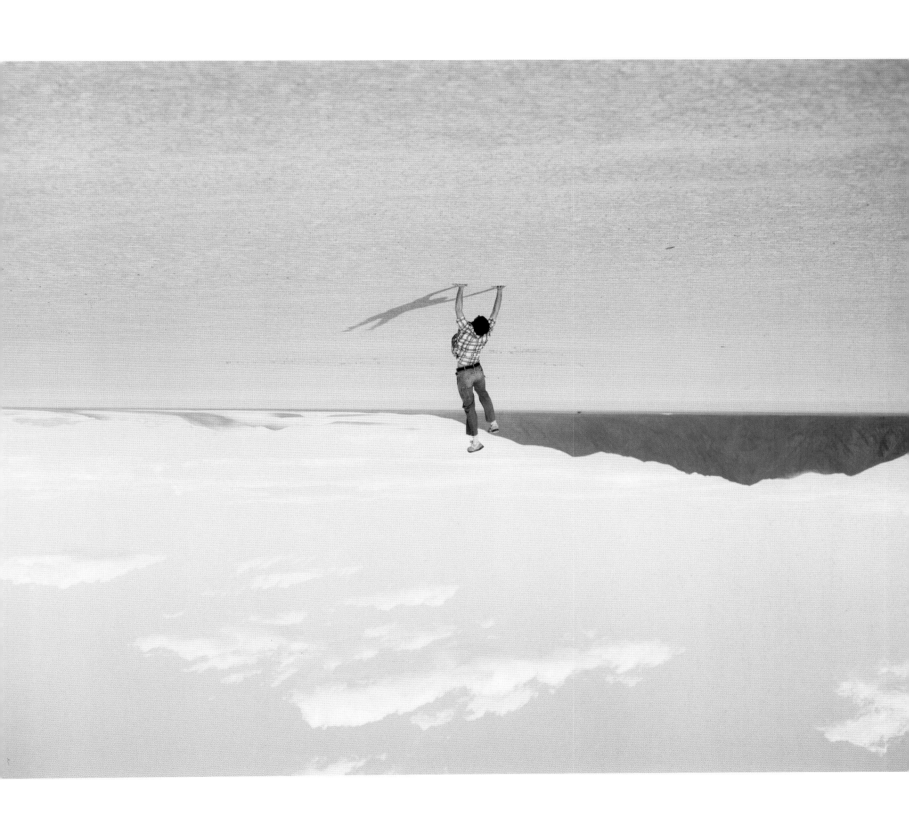

physical *sensation* of time.'[32] To a certain extent Aitken's works describe a similar shift, from meditations on space to an intense interest in time. On the one hand, landscape in the widest sense of the word could be seen as the real issue of his work. One the other, the routes through space that his video works trace are never linear, but hint at elaborate narratives: circular, multi-layered and open-ended. The sense of time out of which these stories are constructed can hardly be understood in terms of a linear succession; other spatial models are needed. Not the space of science, but an experimental space that makes this new flow of events perceptible. In trying to visualize and communicate an alternative conception of time we are forced to adopt alternative spatial metaphors: the fold, the labyrinth, or the Borgesian forking paths.[33]

In Plato's *Timaeus*, time is called the 'moving image of eternity'. It consists of days, nights, months and years: '*They are all parts of time, and the past and the future are created species of time, which we unconsciously but wrongly transfer to eternal being, for we say that it "was", or "is", or "will be", but the truth is that "is" alone is properly attributed to it.*'[34] That which truly *is*, is the eternal Present, the Now. Such is the Platonic teaching, inherited by an entire tradition leading all the way up to modern attempts – such as that of phenomenology – to come to grips with the flow of time. The comet – to return once again to Husserl's image – traces a luminous line. The line represents the succession of now-points, but the *now* itself is constantly new. The comet must be conceived of as constantly reborn, new in every moment. To break

with this powerful linear conception seems to require a spatialization of a different kind. Aitken's recent large-scale installations offer such spatial solutions, the journey through which is never predictable and never the same. Ali Johnson's body in *electric earth* emerges as the product of a technological environment run amok. And the viewer who moves from one segment to the next in this complex cinematic corridor becomes part of the scenario, not only though empathy, but through the physical experience of the work. It's his/her bodily conduct and kinaesthetic experience that determines the rhythms and structure of the work. *electric earth* takes place in and through the viewer's body.

The self is never a given in Aitken's works. Rather, the subject emerges as a complex system of detours and technological mediations. This is related to alternative understandings of time, such as Freud's notion of 'deferred action'. In his analysis, traumatic childhood events acquire their full significance only post-factually, in such a way that one may even claim that they have never been experienced as present, but only in a deferred manner. This temporal syncopation cuts right through the very core of consciousness. It means that *the present is never present*. Or rather, that the consciousness of what is present is never self-present, but always delayed. The mind has no direct line to itself, but must pass through various complicated systems of mediation. Such seems to be the predicament described in Aitken's automated cosmos, where the displacement of the subject in time is a natural consequence of the digitized topography it inhabits.

conspiracy
1998
C-print mounted to Plexiglas
122 × 122 cm

who's under the influence
1999
Diptych

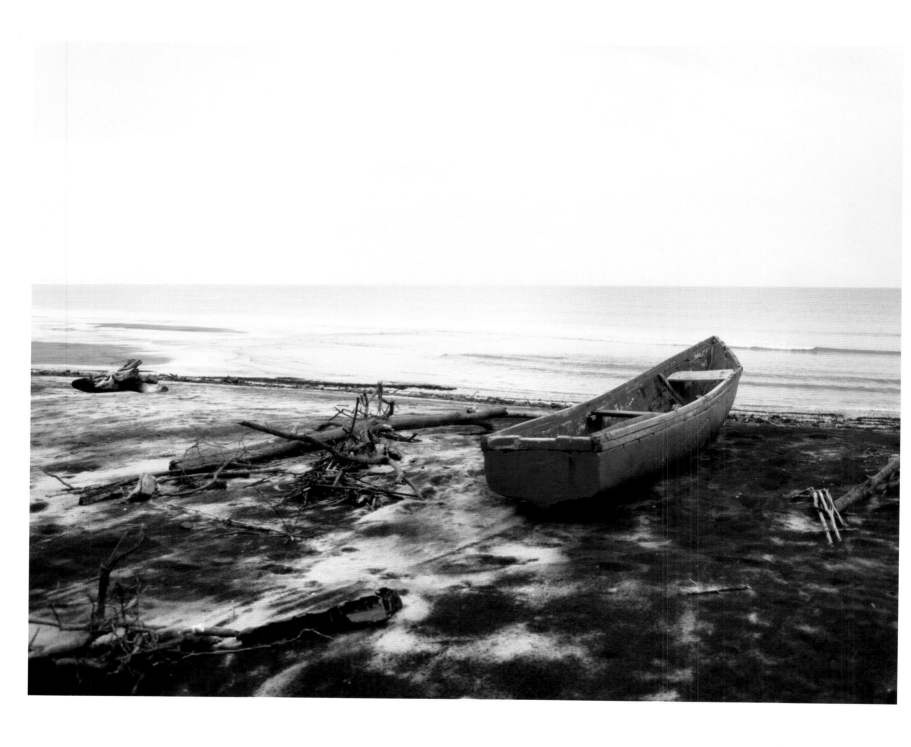

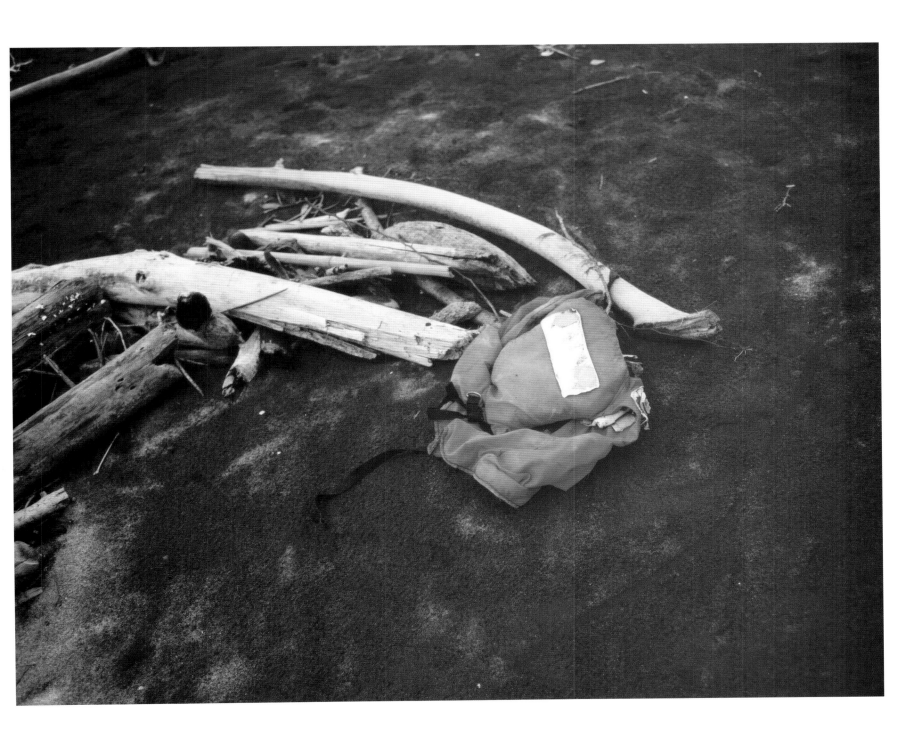

The human eye is equipped with all kinds of machines that widen its reach. But it cannot see itself see – at least not without the help of mirrors or a prosthetic sub-system. Visual technologies abound in Aitken's universe: the film camera; surveillance equipment; radar dishes; the remote control; flickering monitors. To the computer file, sound and vision represent nothing but data to be translated and manipulated freely. Through advanced robotics, the kinaesthetic sensations of the body can be broken down to basic signals. Thus the living body as a last point of reference disappears and a world of freely circulating information is born. One of Aitken's installations, *i am in you*, gives us a glimpse of such a universe. The last agonizing bodily paroxysms that we experienced in *electric earth* are gone. This is a harmonious world of child's play, piano music, and divine geometry. A young girl whispers, 'I like to run and not slow down. I like to see and look.' We see her eyes, over and over again, sometimes in extreme close up. A blue monitor grows and soon covers the whole field of vision, thus producing one of those monochromatic moments typical of Aitken's work. We see bodies falling though space, and aeroplanes sucked into some vortex-like vanishing point at incredible speed. Even if the passage through this five-projection installation is more harmonious than Ali Johnson's nocturnal urban trek, it is by no means without its intense and dramatic moments. All sense of traditional architectural space is gone; we move through a strangely unanchored space where everything floats freely, producing a hallucinatory sense of eternal recurrence. Things attempting to escape

this cosmos are sucked back by a mysterious force. Even time is absorbed this way. A candle burns producing a deafening sound; a car rides along the street with no one at the wheel. The girl's voice whispers over and over again, 'You can't stop.' Who drives this universe, who inverts its course of event? Who am 'I' and who are 'You' in *i am in you*?

Until now most of Aitken's works have explored a specific site with particular histories and memories, so in this sense *i am in you* represents a new departure. *electric earth* had depicted a rather generic urban landscape, but in *i am in you* all sense of geography and locality has evaporated into a cycle of dream-like imagery. If 'I' am not here, living in this body, feeling with these hands and seeing with these eyes, then I am everywhere or nowhere. The philosopher Paul Virilio sums up our predicament in a series of questions: '*For if man's sphere of activity is no longer limited by extension or duration or even opaqueness of obstacles barring his way, where is his presence, his real presence, located? "Tele-presence", no doubt, but where? From what starting point or position? Living-present, here and there at the same time, where am I if I am everywhere?*'[35] Aitken's recent work seems to occur in such a non-site where time and space must be redefined and our presence becomes, 'as random as those phantom particles whose position or speed may perhaps be known, but never both at once' (Virilio).[36] 'You can't stop,' whispers the girl's voice. This is the end of time. Things disappear into the vortex of experience. Again and again. It is your experience, and you can't stop.

1 Gilles Deleuze, *Cinema 2: The Time-Image*, trans. Hugh Tomlinson and
 Robert Galeta, University of Minnesota Press, Minneapolis, 1989

2 Robert Irwin, cited in Lawrence Weschler, *Seeing is Forgetting the
 Name of the Thing One Sees*, University of California Press, Berkeley,
 1982, p. 4

3 Paul Virilio, *Polar Inertia*, Sage, London, 2000, p. 38

4 Saul Anton and Doug Aitken, 'A Thousand Words', *Artforum*, New
 York, May, 2000

5 Gilles Deleuze, *The Fold: Leibniz and the Baroque*, University of
 Minnesota Press, Minneapolis, 1992

6 Jorge Luis Borges, *Labyrinths*, Penguin, London, 1970, p. 53

7 Francesco Bonami, 'Doug Aitken: Making Work without Boundaries',
 Flash Art, Milan, May–June, 1998, p. 80

8 Jörg Heiser, 'Mercury Rising: On Doug Aitken's Digitized
 Topography', lecture at the conference 'Lost Horizons', Camberwell
 College of Arts, Spring, 2000

9 Francesco Bonami, 'Doug Aitken', op. cit.

10 Sigmund Freud, 'Beyond the Pleasure Principle', *The Standard Edition
 of the Complete Works of Freud*, ed. J. Strachey with Anna Freud, 24
 Vols., Hogarth Press, London, 1953–64

11 The author in conversation with the artist, February, 2001.

12 Samuel Beckett, 'The Unnameable', in *Three Novels*, Grove Press, New
 York, 1965, 386 ff.

13 G.W. Leibniz, *Philosophical Texts*, trans. and ed. by R. S. Woolhouse
 and Richard Francks, Oxford University Press, 1998, p. 277

14 Gilles Deleuze, *The Fold: Leibniz and the Baroque*, op. cit.

14 *Artforum*, New York, May, 2000

16 Ibid.

17 Doug Aitken, 'Into the Sun: Overview', in *Video Cult/ures*, ed. Ursula
 Frohne, DuMont, Cologne, 1999, pp. 162–63

18 Ibid.

19 Ibid.

20 Ibid.

21 Douglas Fogle, 'No Man's Lands', *frieze*, No. 39, London, 1998

22 The work in question is *eraser* (1998). Quoted from *Cross: Quarterly of
 Visual Arts and Contemporary Culture*, No. 2, Cremona, 1999

23 Ibid.

24 For a comparison between the Romantic landscape and Abstract
 Expressionism, see Robert Rosenblum, *Modern Painting and the
 Romantic Tradition: Friedrich to Rothko*, Thames and Hudson, London,
 1975

25 Francesco Bonami, 'Doug Aitken', op. cit.

26 Robert Smithson, *The Writings of Robert Smithson*, ed. Nancy Holt,
 New York University Press, 1979, p. 221

27 Ibid., p. 219

28 Doug Aitken and Dean Kupiers, *I Am a Bullet: Scenes from an
 Accelerating Culture,* Crown Publishers, New York, 2000

29 Barnett Newman, *Selected Writings and Interviews*, ed. John P.
 O'Neill, Knopf, New York, 1990, p. 173

30 Gilles Deleuze, *Cinema 2: The Time-Image*, op. cit., p. 278

31 Jörg Heiser notes this inversion of the Romantic notion of landscape
 as projection, and adds: 'One can denounce this as a quite
 complicated form of opportunism, or praise it as subversive stealth,
 and truth certainly lies in a precarious ambivalence in between.'

32 Barnett Newman, *Selected Writings and Interviews*, op. cit., p. 175

33 Jorge Luis Borges, *Labyrinths*, op. cit., p. 53

34 Plato, *Timaeus* 37 E in *The Collected Dialogues*, ed. E. Hamilton and H.
 Cairns, Princeton University Press, 1961.

35 Paul Virilio, *Polar Inertia*, op. cit., p. 83

36 Ibid.

**decease the mass and run like
hell**
1999
Mirror kite and poster
opposite, poster, 50 × 39.5 cm
left, kite, 86.5 × 85 cm; tail 95 cm

following pages, left, **the mirror**
1998
Digital C-prints mounted to
Plexiglas
76 × 89 cm each

following pages, right, **over the
ocean**
2000
Digital C-print mounted to
Plexiglas
167.5 × 122 cm

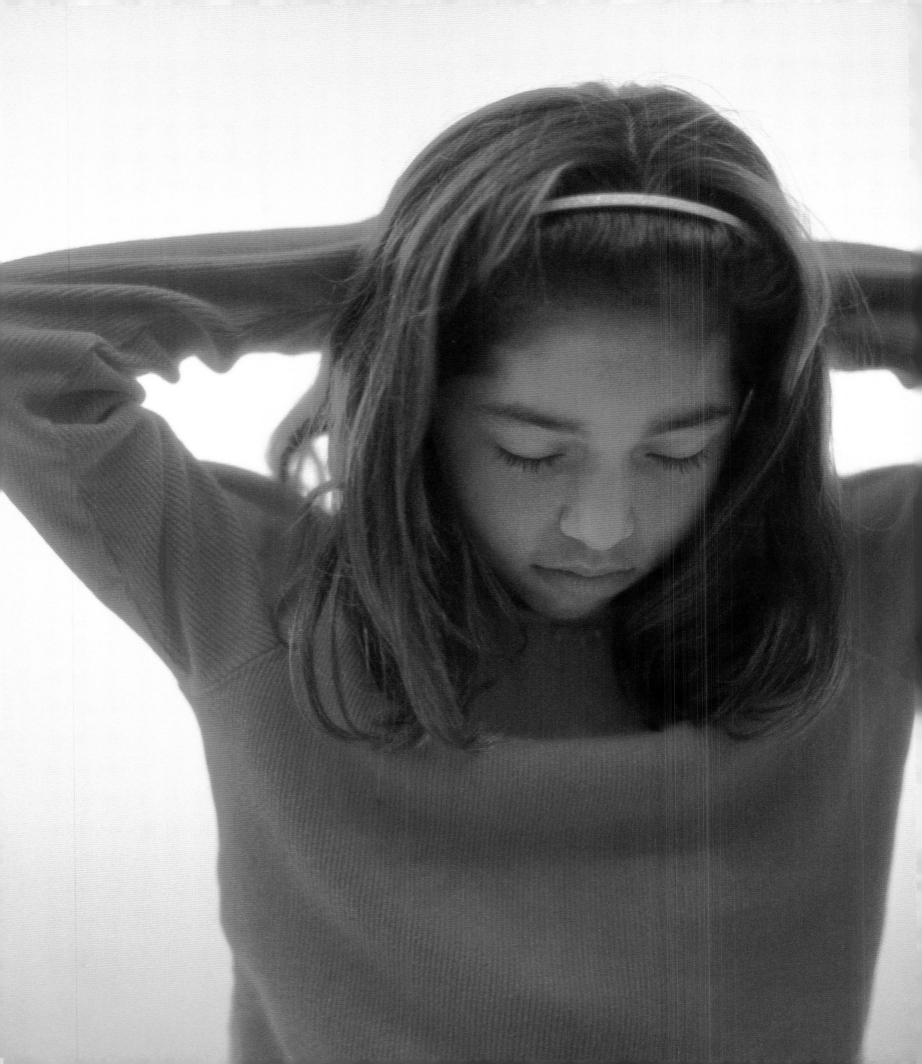

Contents

In Doug Aitken's work, one or two simple sentences can arouse a myriad of pictures and perceptions. 'That's the only now I get', and 'A lot of times I dance so fast I become what's around me', says the protagonist of *electric earth* (1999) before he sets out to prove it. He tunes in to the depopulated night-time cityscape like a radio, though a radio that is not passively receiving, but actively altering the tunes. As he falls into something like a telekinetic electric boogie, car windows move up and down, and surveillance cameras jiggle in hyperactive convulsion.

'You got to run as fast as you can all of the time' and 'You got to be sharp!', whispers the girl in the opening scene of *i am in you* (2000). She is maybe ten or eleven (though the age seems unimportant), but sitting there cross-legged in the red gloom, with her eyes moving fast, at first in sharp focus, then half-closed while she comfortably undulates her shoulders, she seems so deep in relined concentration that it sounds like wishes to be granted by no one but herself.

'You got to run as fast as you can all of the time.' The 'you' is suddenly you, the beholder, as you move through the piece, trying to keep up with the quick-changing orchestration continually unfolding all around. It emits light, it hums, images bleed through one another, ghost images of what seems other moments in time, other places. This is not chaos, there's a rhythm to it that you haven't quite locked in to yet, but you know you will in an instant. It's not the legs that run but your perceptive processes, you navigate a ground plan somewhat similar to an LED-display 'S': a set of five screens, three parallel from front to back, the second of them free-standing in the centre of the space, the remaining two staggered to the left and right. The whispered 'run' suddenly sounds a lot like 'learn', as the girl's multiplied image alternates quickly with what looks like roof trusses fanned out against a black background and lit up in a precise staccato. She herself seems to be a flash camera capturing the geometrical forms that rule their statics. 'Pattern recognition' is what sociologists zealously call this, often imagining themselves as the parents defining the conditions of the experiment.

In *i am in you*, its like an early learning high chair game is set free from parental guidance, and has developed dramatically into a complex set of sequences smoothly collapsing into one another. A shot from the back seat of a limousine as it moves slowly through the blue of the wee small hours: the driver's seat is empty, the wheel steered as if by

i am in you
2000
Colour film transferred to 3
channel digital video installation,
5 projections, colour, sound
11 min. 3 sec. cycle
Collection, Kanazawa City
Museum, Japan
Installation, Galerie Hauser &
Wirth & Presenhuber, Zurich

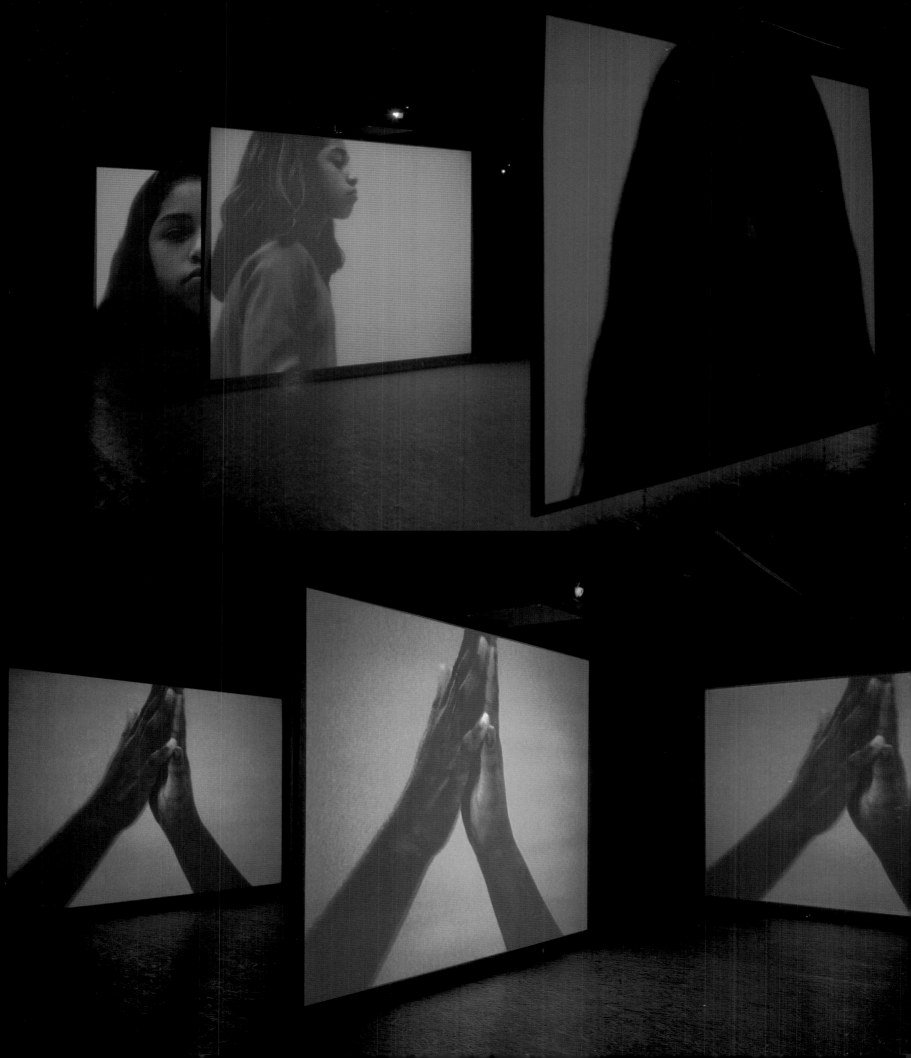

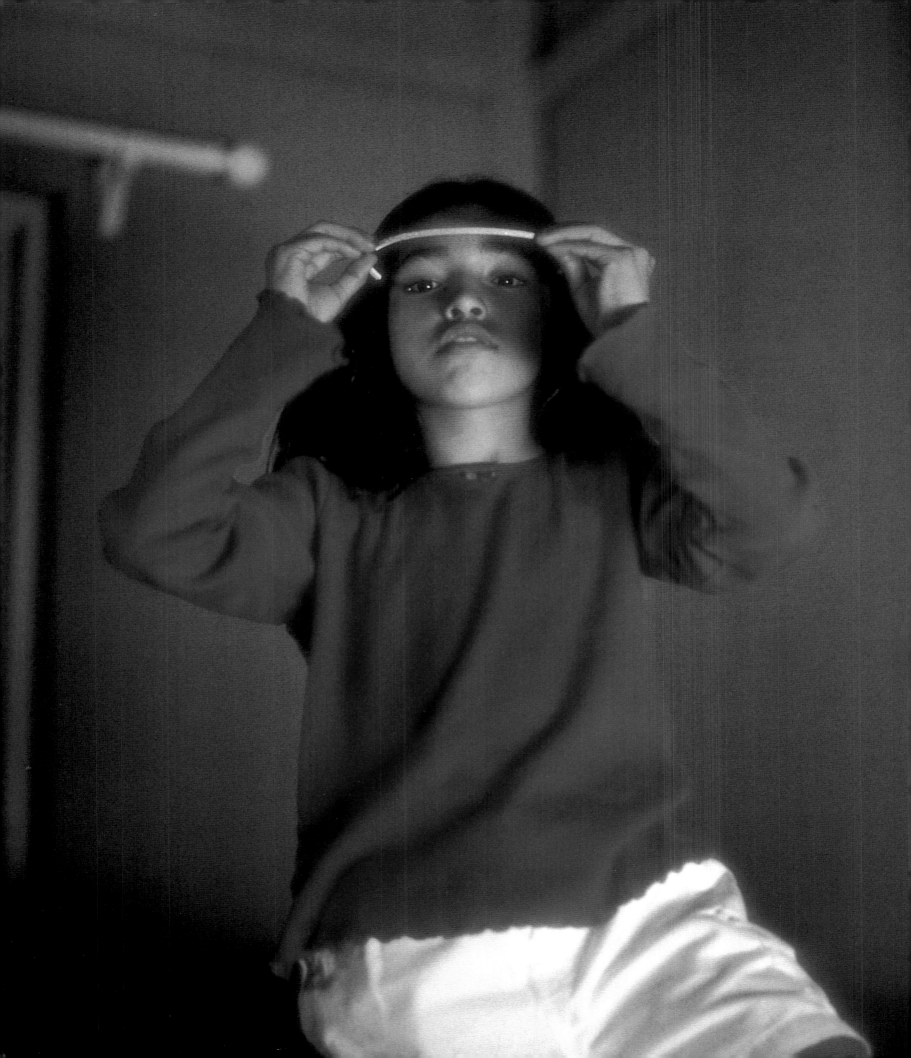

ghost's hands. As the centre image zooms away from a close-up of the girl's face, it reveals that she is sitting in the back of the car. The other four screens switch to her hands going through the rhythmic motions of a hand-clapping game with another girl, on the same back seat shot through with flash-backs of the geometric structures as if they were conjured up by the awkward rhythmic movements. The image of the hands clapping is transferred to the centre, and the broken circle of the other four screens again show the orphaned steering wheel.

Suddenly, amidst the chaos of the present experience, you notice a dynamic of osmosis taking place between the screen in the middle of the space and the four screens around it. The work has a simultaneously organic and geometric feel to it, an architecture truly set in motion by editing: like a glowing, Buckminster-Fullerish jellyfish pumping gently through a black sea. This is a modular architecture, a gently rickety folding chair that is turned on its side and multiplied around its hinge. At the same time, it's an architecture of negativity, where the black void outlining the images is both surface and infinite space, like Boullée's late eighteenth-century vision of an architecture of shadows steeped in the ground. There is a general impulse of moving however, from one sequence to the other, alternately infused at the centre and the edge, with smaller counter-impulses – not least from the music – constantly shoring up the provisional balance.

It becomes apparent that this architectural osmosis equals a constant inversion of the perceptive realm. It's like what the phenomenologist Maurice Merleau-Ponty called a chiasm, a kind of 'double-dialectics', a reciprocal relation that is twisted around its axis. The centre screen is not simply the representation of the girl's psychological 'inside', with the screens around representing the 'outside' world; nor the other way round. Rather, perception is the movement in-between, like a process of expanding and contracting – time and space as such seem to be expanding and contracting – building and breaking down, one moment blurring the line between 'I' and 'You', the girl and the world, the next moment sharply delineating it. That is what the title *i am in you* really captures: hand in glove is suddenly also glove in hand.

It's as if the old phenomenological question – What came first, I or the other; bodily perception or social interaction? – is answered in the dream-like sequence of a night-time swimming pool. Standing in the water, the girl and two other kids again play a hand-

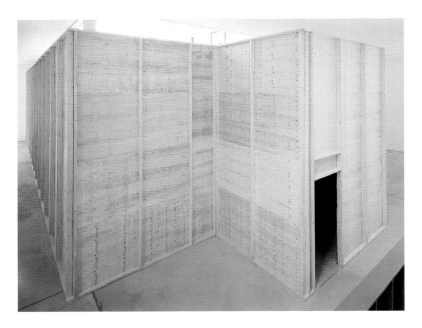

clapping game, forming a casual triangle as if in a secular seance: the interrelation between 'I' and 'You' is not one of cause and effect, it always already includes the involvement of at least a third coordinate, whether it's the presence of a concrete entity or the world at large.

i am in you
2000
Colour film transferred to 3 channel digital video installation, 5 projections, colour, sound
11 min. 3 sec. cycle
Collection, Kanazawa City Museum, Japan
left, exterior view of installation, Kunst-Werke, Berlin, 2001
opposite, work in progress
following pages, installation, Galerie Hauser & Wirth & Presenhuber, Zurich

The girl, swimming on her back, looks up into the sky, as aeroplanes are quickly moving away like shooting stars. The brief fragments of electronic music, wavering gently like the deep blue night-time surface of water , cross-fade into a piano playing Bach – the seminal sound of learning patterns unfolding in mathematical elegance. She whispers 'You can't stop', as if she already knew that perception will have to sharpen again soon to stay on top of the complexities. It's the constant search for structure and order in the chaos around, in the 'Now', with no nostalgia or future Utopia to take refuge in. *i am in you* makes time feel like a modular, multi-track recording, both simultaneous and out-of-sync, yet with clear structure – an echo chamber spiraling off into deep space. Generally speaking, sound in fact *is* where time and space touch: no wonder architecture has notoriously been compared to music in the way it organizes movement.

A harsh saw-tooth synth-bass line sets in, a pupil contracts, the geometric patterns return, images that had just been patted like a pet on its back are slammed frontally into one another, before being replaced gradually by another game of patterns: cat's cradle, woollen yarn distributed between hands as if webbing provisional architectures.

It's not just any kind of 'universal' perception, the 'I' and 'You' of *i am in you* are constantly trying to develop and perfect themselves – rather, it's like running uphill on a spiral timeline of technology – or is it downwards, into the maelstrom? Absorbed in the 'Now' of reacting to the effects of this automatism of history, it's like time itself has become a black hole, bringing our ways of speaking, miming, moving to a warping halt, and speeding them up at the same time. The funny thing is it seems it's possible to enjoy this harsh, make-

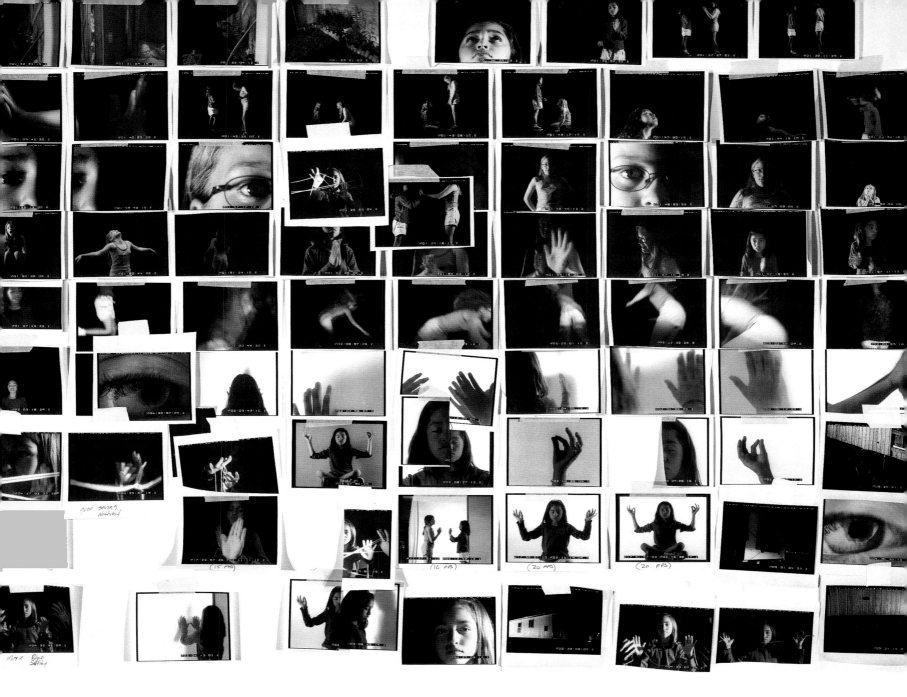

shift process on the way: an image of the girl turning in circles, arms spread and face upwards, as if she was a turning record, playing a song of transitory places, visualized in accelerated zooms of airport check-in zones.

Can you really build a place called home on the quicksand of constant change? Candles burning calmly is the almost ironical answer, making you feel romantically relieved for the moment. Yet out of the comforting silence, an earthworm of white noise is rearing its head. And then the brief glimpse of a one-storey house, the wood-panel facade floodlit at night, followed by close-ups of the girl sitting on the floor with a game console. Again, her eyes are deeply concentrated, but her hands are not moving, and the monitor shows nothing but the interim blue you get to see when nothing is on. She is not retreating from perception, but

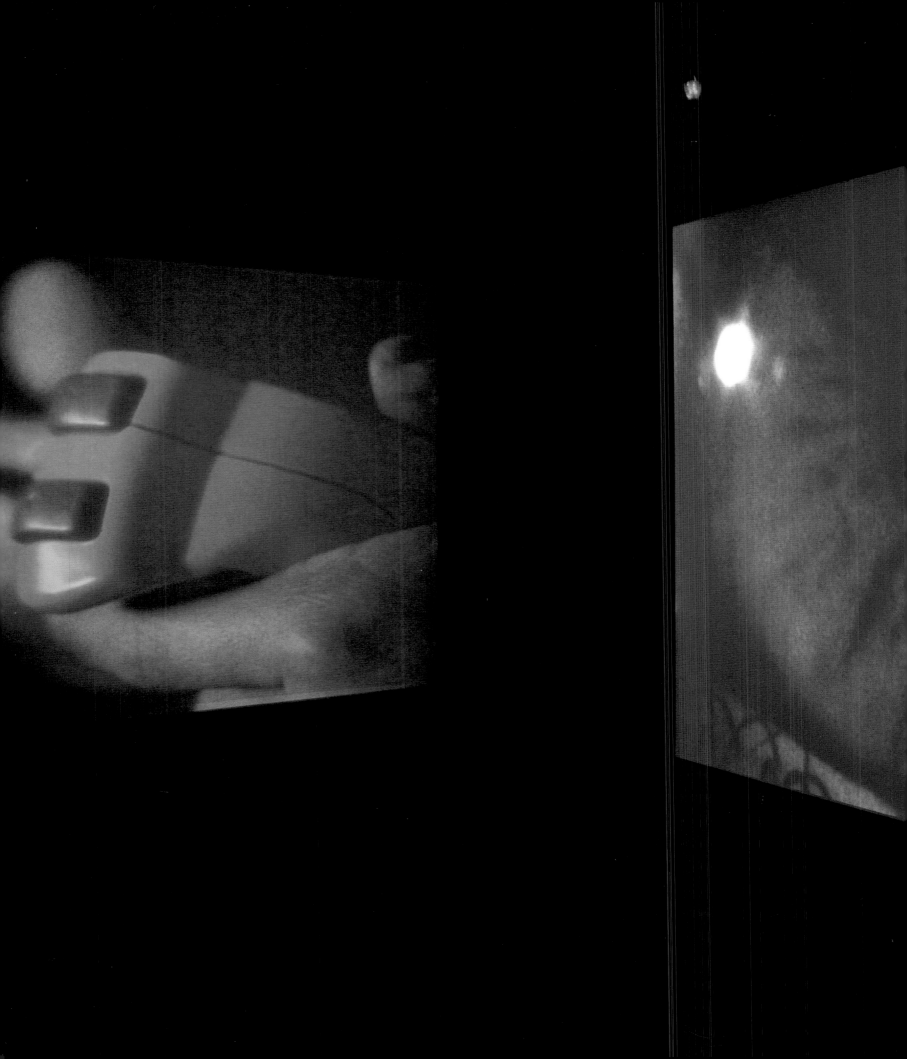

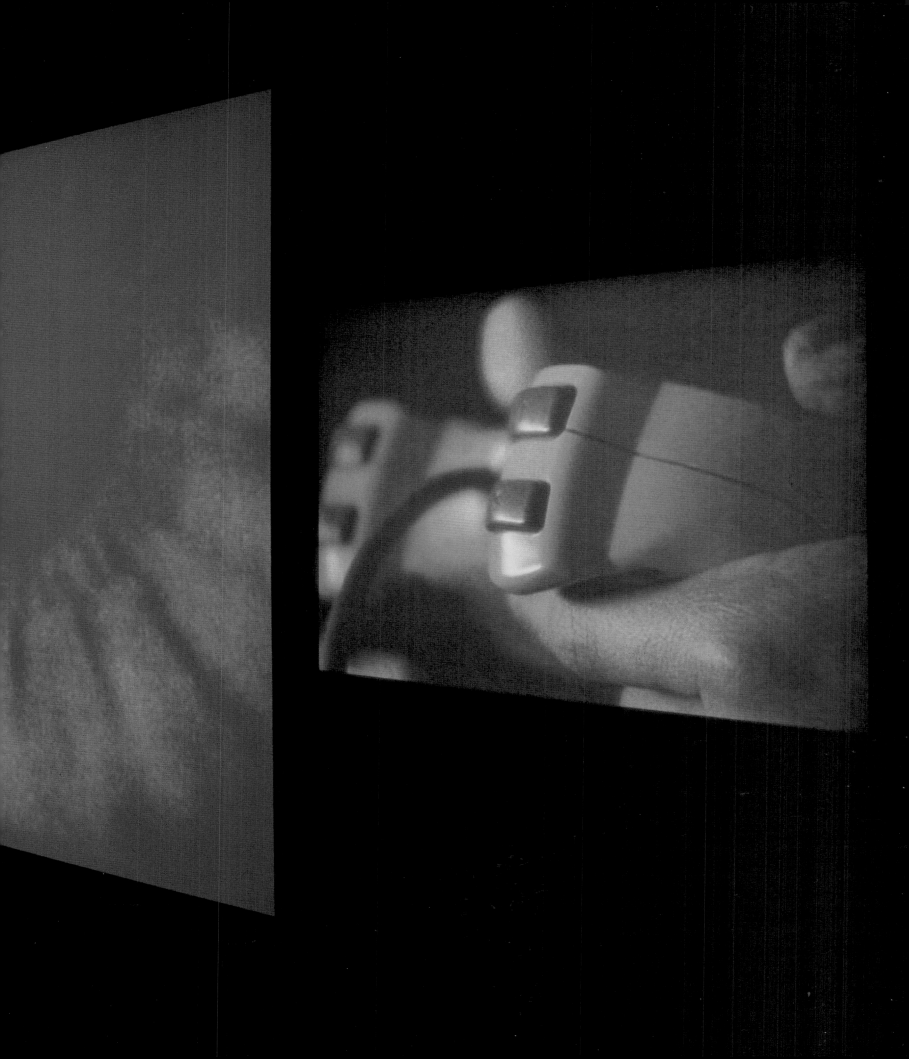

making sense of it: closing her eyes, she recalls the hand clapping schemes, her companion vanishing behind a milk glass filter, as if to gate the illusion of being able to fully understand the other. Images of hands drawing elegant geometrical patterns with a set of Spirograph stencils on a light box seem to picture this invisible activity of digestion. If there is a place called home, it is in these moments of retroactive comprehension, dozing over into sleep.

i am in you
2000
3 channel laserdisc installation, 5 projections, colour, sound
11 min. 3 sec. cycle
Collection, Kanazawa City Museum, Japan
opposite, installation, Galerie Hauser & Wirth & Presenhuber, Zurich

But even this phase of comfort, rest and 'home' is about to be set in motion. 'You can't stop', the girl whispers even as she is apparently sleeping, cushioned by duvets and dreams. The mechanics of change seem to continue warping and creaking like the timberwork, as invisible hands are operating a hydraulic jack. The very same shot of the one-storey house, yet suddenly it's moving, dragged away like it's a trailer. The next shot reveals that the house is half a house, cut right down its longitudinal axis like a cake, as if by the hands of a generic

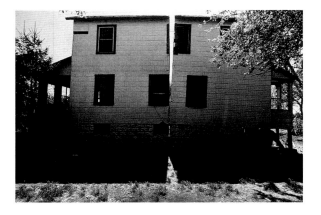

Gordon Matta-Clark
Splitting
1974
322 Humphrey Street, Englewood, New Jersey
Documention photograph

sibling of Gordon Matta-Clark, just in order to make it fit on two trucks that are now driving along the highway. The girl seems not at all disturbed, rather gently rocked into an even deeper sleep. Sounds fade in and out like in a best-of medley of her perceptive day: Bach, cars speeding up like busy bees, white noise, hands clapping, the warm crackle of a record groove. The lights of cars rushing by vanish into a ghostly haze of oblivion.

i am in you is a piece bringing to a head a question that has always been latently present in Doug Aitken's work: how do people's perceptions of time and space interlock with technologies of media and infrastructure, how is the one effecting the other? The eager prophets of the 'new economy', and the working world it entails, have long predicted that learning will not remain something that is finished once you graduate, but become something you will have to do all of your life, constantly. You're learning flexible form, not hard content. The question though is what you're learning for. Is it to fulfil the dreams of a decent descendant? or some automated hierarchy's habits? 'You're learning not for school, but for life', is a parental commonplace for trying to motivate the unwilling. With the sting of patronization seemingly removed, learning with *i am in you* means understanding the machineries and their structure while already projecting new ones. There is something very

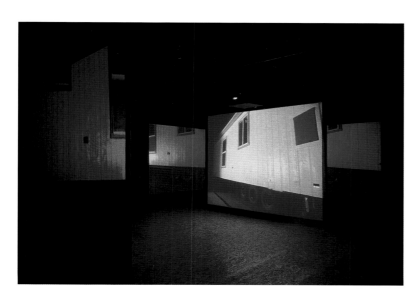
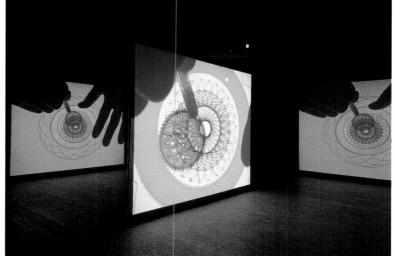

ambivalent about this: you could see yourself preparing, while pep-talking yourself into being constantly on the move and on alert, to become a future combat warrior of the marketplace – and either thoughtlessly fulfil or violently resist its compulsory logic of profit. Living is a precarious ping-pong in-between, something maybe best visualized in a scene from another video installation by Aitken, *blow debris* (2000): a tennis court bathed in floodlight, a naked man is playing. He looks handsome, trained, a bit like a cross between Jim Morrison and a successful art director. He is playing against a ball-serving machine, at first seemingly relaxed, keeping up with the accelerating pace of balls flying. But gradually he's turning red, veins and tendons protruding, as if straining himself to become a machine, in order to keep up with the robotic opponent. It's as if the off- and on-court demand of 'flexibility' is about to be taken to the point where it collapses into a trembling stasis.

In 1844, William Turner captured the early symbol of the newly developing industrial-military complex when he painted his famous *Rain, Steam and Speed – The Great Western Railway*, bathing it in a turmoil of Midas golden light; about 125 years later, Smithson set out to dig up the already half-buried remains of the industrial; meanwhile, McLuhan and Warhol embraced the media technologies of repetition and feedback that had already transformed the industrial into something else. Against this historic background, Doug Aitken's *electric earth*, *i am in you* and *blow debris* together from a kaleidoscopic triptych of the drama of living in a digitized, fragmented environment – where space is taken hostage and time is stuffed into the tumbler.

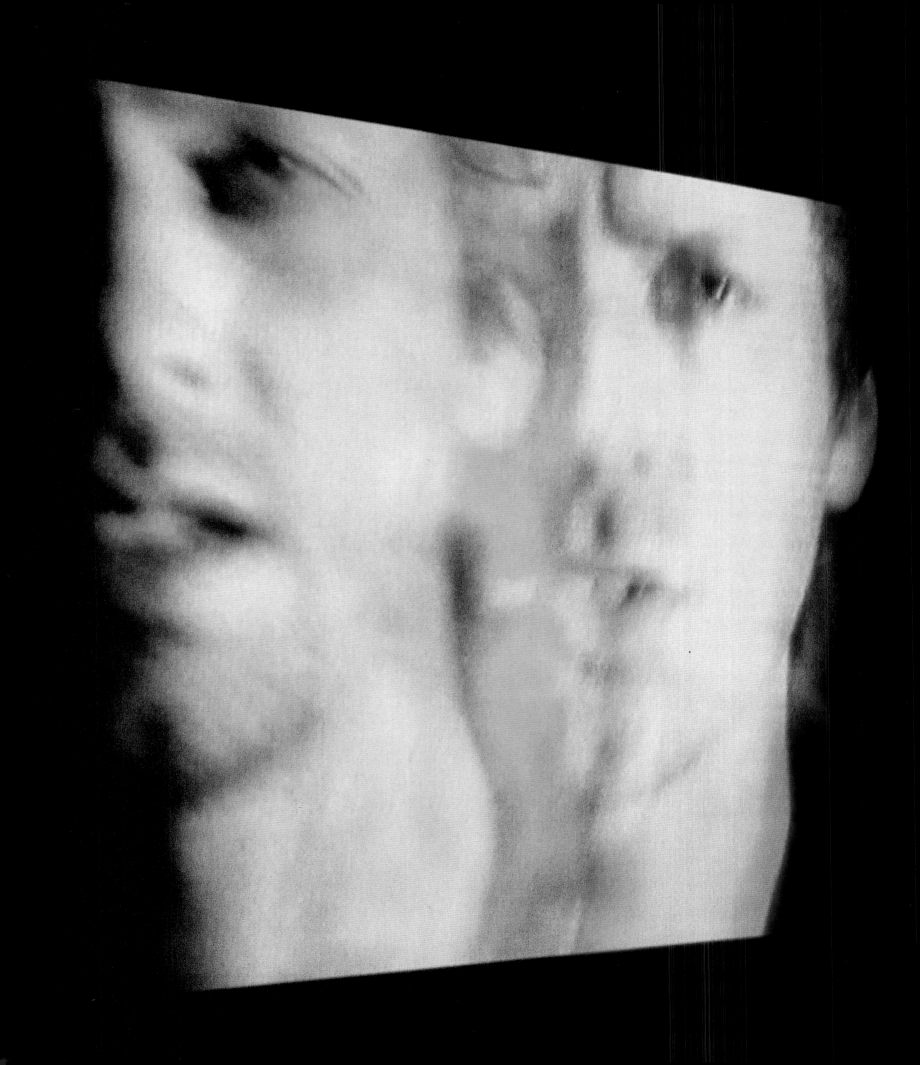

Contents

[…] My first memory of Funes is very perspicuous. I can see him on an afternoon in March or February of the year 1881. My father, that year, had taken me to spend the summer in Fray Bentos. I was returning from the San Francisco ranch with my cousin Bernardo Haedo. We were singing as we rode along and being on horseback was not the only circumstance determining my happiness. After a sultry day, an enormous slate-coloured storm had hidden the sky. It was urged on by a southern wind, the trees were already going wild; I was afraid (I was hopeful) that the elemental rain would take us by surprise in the open. We were running a kind of race with the storm. We entered an alleyway that sank down between two very high brick sidewalks. It had suddenly got dark; I heard some rapid and almost secret footsteps up above; I raised my eyes and saw a boy running along the narrow and broken path as if it were a narrow and broken wall. I remember his baggy gaucho trousers, his rope-soled shoes, I remember the cigarette in his hard face, against the now limitless storm cloud. Bernardo cried to him unexpectedly: 'What time is it, Ireneo?' Without consulting the sky, without stopping, he replied: 'It's four minutes to eight, young Bernardo Juan Francisco.' His voice was shrill, and mocking.

I am so unperceptive that the dialogue I have just related would not have attracted my attention had it not been stressed by my cousin, who (I believe) was prompted by a certain local pride and the desire to show that he was indifferent to the other's tripartite reply.

He told me the fellow in the alleyway was one Ireneo Funes, known for certain peculiarities such as avoiding contact with people and always knowing what time it was, like a clock. He added that he was the son of the ironing woman in town, María Clementina Funes, and that some people said his father was a doctor at the meat packers, an Englishman by the name of O'Connor, and others that he was a horse tamer or scout from the Salto district. He lived with his mother, around the corner from the Laureles house.

During the years eighty-five and eighty-six we spent the summer in Montevideo. In eighty-seven I returned to Fray Bentos. I asked, as was natural, about all my acquaintances and, finally, about the 'chronometrical' Funes. I was told he had been thrown by a half-tamed horse on the San Francisco ranch and was left hopelessly paralyzed. I remember the sensation of uneasy magic the news produced in me: the only time I had seen him, we were returning from San Francisco on horseback and he was running along a high place; this fact, told me my cousin Bernardo, had much of the quality of a dream made up of previous elements. I was told he never moved from his cot, with his eyes fixed on the fig tree in the back or on a spider web. In the afternoons, he would let himself be brought out to the window. He carried his pride to the point of acting as if the blow that had felled him were beneficial … Twice I saw him behind the iron grating of the window, which harshly emphasized his condition as a perpetual prisoner: once, motionless, with his eyes closed; another time, again motionless, absorbed in the contemplation of a fragrant sprig of santonica […]

Ireneo told me that before that rainy afternoon when the blue-gray horse threw him, he had been what all humans are: blind, deaf, addlebrained, absent-minded. (I tried to remind him of his exact perception of time, his memory for proper names; he paid no attention to me.) For nineteen years he had lived as one in a dream: he looked without seeing, listened without hearing, forgetting everything, almost everything. When he fell, he became unconscious; when he came to, the present was almost intolerable in its richness and sharpness, as were his most distant and trivial memories. Somewhat later he learned that he was paralyzed. The fact scarcely interested him. He reasoned (he felt) that his immobility was a minimum price to pay. Now his perception and his memory were infallible.

We, at one glance, can perceive three glasses on a table; Funes, all the leaves and tendrils and fruit that make up a grape vine. He knew by heart the forms of the southern clouds at dawn on the 30th April, 1882, and could compare them in his memory with the mottled streaks on a book in Spanish binding he had only seen once and with the outlines of the foam raised by an oar in the Río Negro the night before the Quebracho uprising. These memories were not simple ones; each visual image was lined to muscular sensations, thermal sensations, etc. He could reconstruct all his dreams, all his half-dreams. Two or three times he had reconstructed the whole day; he never hesitated, but each reconstruction had required a whole day. He told me: 'I

the inextinguishable i
1999
C-print mounted on Plexiglas
94.5 × 122 cm

the inextinguishable ii
1999
C-print mounted on Plexiglas
94.5 × 122 cm

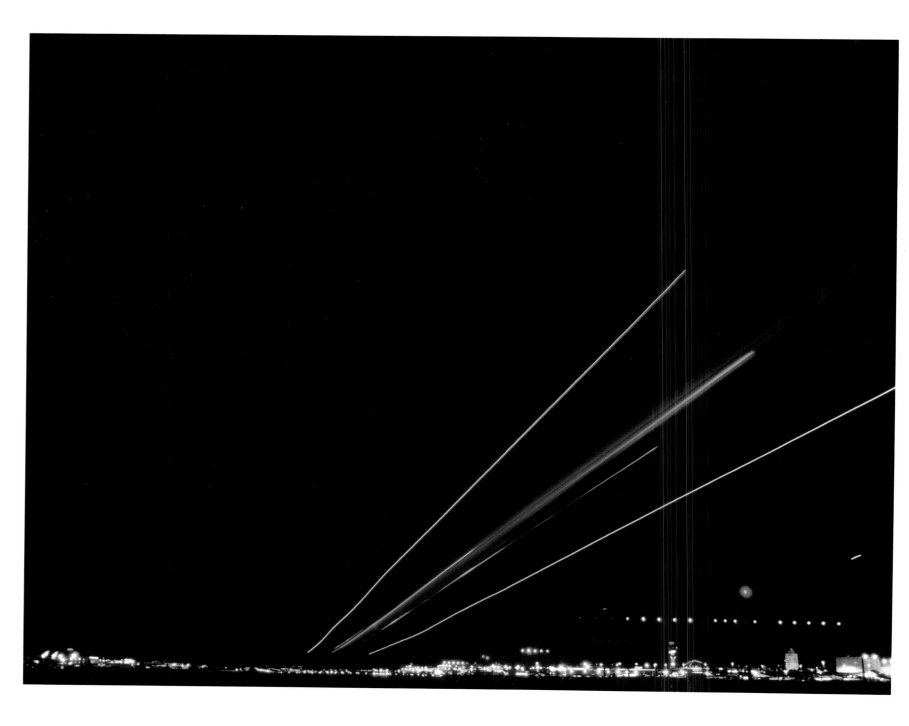

126

collision x1
1999
Digital C-print mounted on
Plexiglas and floating frame

alone have more memories than all of mankind has probably had since the world has been the world.' And again: 'My dreams are like you people's waking hours.' And again, towards dawn: 'My memory, sir, is like a garbage heap'. A circle drawn on a blackboard, a right triangle, a lozenge – all these are forms we can fully and intuitively grasp; Ireneo could do the same with the stormy mane of a pony, with a herd of cattle on a hill, with the changing fire and its innumerable ashes, with the many faces of a dead man throughout a long wake. I don't know how many stars he could see in the sky.

These things he told me; neither then nor later have I ever placed them in doubt. In those days there were no cinemas or phonographs; nevertheless, it is odd and even incredible that no one ever performed an experiment with Funes. The truth is that we live out our lives putting off all that can be put off; perhaps we all know deep down that we are immortal and that sooner or later all men will do and know all things.

Out of the darkness, Funes' voice went on talking to me. He told me that in 1886 he had invented an original system of numbering and that in a very few days he had gone beyond the twenty-four thousand mark. He had not written it down, since anything he thought of once would never be lost to him. His first stimulus was, I think, his discomfort at the fact that the famous thirty-three gauchos of Uruguayan history should require two signs and two words, in place of a single word and a single sign. He then applied this absurd principle to the other numbers. In place of seven thousand thirteen, he would say (for example) *Máximo Pérez*; in place of seven thousand fourteen, *The Railroad*; other numbers were *Luid Melián Lafinur, Olimar, sulphur, the reins, the whale, the gas, the caldron, Napoleon, Agustín de Vedia*. In place of five hundred, he would say *nine*. Each word had a particular sign, a kind of mark; the last in the series were very complicated ... I tried to explain to him that this rhapsody of incoherent terms was precisely the opposite of a system of numbers. I told him that saying 365 meant saying three hundreds, six tens, five ones, an analysis which is not found in the 'numbers' *The Negro Timoteo* or *meat blanket*. Funes did not understand me or refused to understand me. Locke, in the seventeenth century, postulated (and rejected) an impossible language in which each individual thing, each stone,

each bird and each branch, would have its own name; Funes once projected an analogous language, but discarded it because it seemed too general to him, too ambiguous. In fact, Funes remembered not only every leaf of every tree of every wood, but also every one of the times he had perceived or imagined it. He decided to reduce each of his past days to some seventy thousand memories, which would then be defined by means of ciphers. He was dissuaded from this by two considerations: his awareness that the task was interminable, his awareness that it was useless. He thought that by the hour of his death he would not even have finished classifying all the memories of his childhood.

The two projects I have indicated (an infinite vocabulary for the natural series of numbers, a useless catalogue of all the images of his memory) are senseless, but they betray a certain stammering grandeur. They permit us to glimpse or infer the nature of Funes' vertiginous world. He was, let us not forget, almost incapable of ideas of a general, Platonic sort. Not only was it difficult for him to comprehend that the generic symbol *dog* embraces so many unlike individuals of diverse size and form; it bothered him that the dog at three fourteen (seen from the side) should have the same name as the dog at three fifteen (seen from the front). His own face in the mirror, his own hands, surprised him every time he saw them. Swift relates that the emperor of Lilliput could discern the movement of the minute hand; Funes could continuously discern the tranquil advances of corruption, of decay, of fatigue. He could note the progress of death, of dampness. He was the solitary and lucid spectator of a multiform, instantaneous and almost intolerably precise world. Babylon, London and New York have overwhelmed with their ferocious splendor the imaginations of men; no one, in their populous towers or their urgent avenues, has felt the heat and pressure of a reality as indefatigable as that which day and night converged upon the hapless Ireneo, in his poor South American suburb. It was very difficult for him to sleep. To sleep is to turn one's mind from the world; Funes, lying on his back on his cot in the shadows, could imagine every crevice and every molding in the sharply defined houses surrounding him. (I repeat that the least important of his memories was more minute and more vivid than our perception of physical pleasure or physical torment.) Towards the east, along a stretch not yet divided into blocks, there were new houses, unknown to Funes.

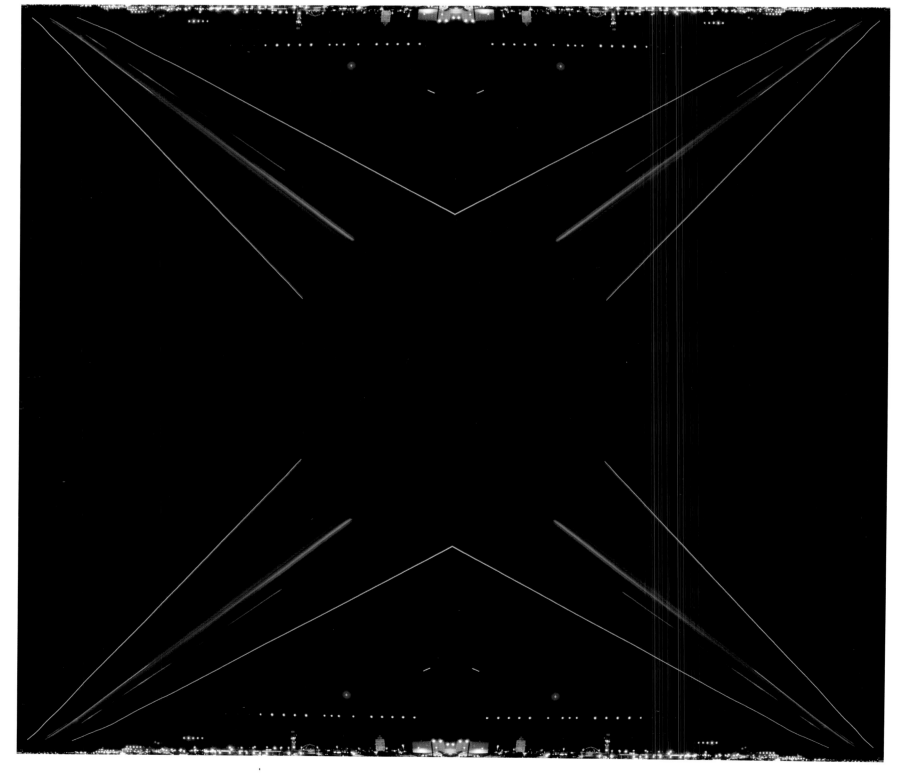

He imagined them to be black, compact, made of homogenous darkness; in that direction he would turn his face in order to sleep. He would also imagine himself at the bottom of the river, rocked and annihilated by the current.

With no effort, he had learned English, French, Portuguese and Latin. I suspect, however, that he was not very capable of thought. To think is to forget differences, generalize, make abstractions. In the teeming world of Funes, there were only details, almost immediate in their presence.

The wary light of dawn entered the earthen patio.

Then I saw the face belonging to the voice that had spoken all night long. Ireneo was nineteen years old; he had been born in 1868; he seemed to me as monumental as bronze, more ancient than Egypt, older than the prophecies and the pyramids. I thought that each of my words (that each of my movements) would persist in his implacable memory; I was benumbed by the fear of multiplying useless gestures.

Ireneo Funes died in 1889, of congestion of the lungs.

Translated by James E. Irby

collision x4
2000
Digital C-print mounted on
Plexiglas and floating frame
122 × 137 cm

Artist's Writings Doug Aitken

screen 2001

it's 11:45 p.m. i'm sitting at a truckstop in the mojave desert. the night sky is ink black, but still it's scorching hot. The heat keeps my eyes open but my tired body resists. I don't plan to be here long.

i talk with a husband-and-wife long-haul trucker team. these are couples who live together in the same cab and drive in shifts, driving round the clock. they sit across me in an empty long-haul truckstop, refuelling their trucks and bodies simultaneously, ready to move on. i had heard that a trucker can always tell you where on the road to get the best meals and the best pies. yesterday i asked a driver named flint for the best places to eat, but he told me every truckstop is owned by the same corporate franchise, 'so you can be sure you'll get the same good meal every time'.

i feel oddly at home in these places. i know i'll find no one i know in the vinyl booth. the husband-and-wife long-haul trucker team I meet there are maybe in their 50s, but it's hard to tell someone's age when they're constantly in motion. he's tall, lanky – a skinny guy, in weathered wrangler jeans. she's soft and a little overweight. he orders a quick coffee, then takes off for the coin-operated showers, leaving her alone at the table. as i watch her i begin to pick up on something intense within her soft exterior. i study the contours of her face, the outline of her skull. sharp, hard lines begin to surface under her fixed expression. she stares out the window for a while before noticing me.

We exchange a few casual and trivial words. i ask:

'are you married?'
'do you drive together?'
'as a team?'
'what's that like?'
'is it ok?'
'do you enjoy it?'
'what's it like being in the same cab, the same space, all day long, with your husband?'
she answers, staring through the window at the dark parking lot outside.

our eyes locked momentarily. there is something melancholic about her. i can tell she wants to talk. i am open.

the movement
2000
C-print mounted on Plexiglas
101.5 × 127 cm

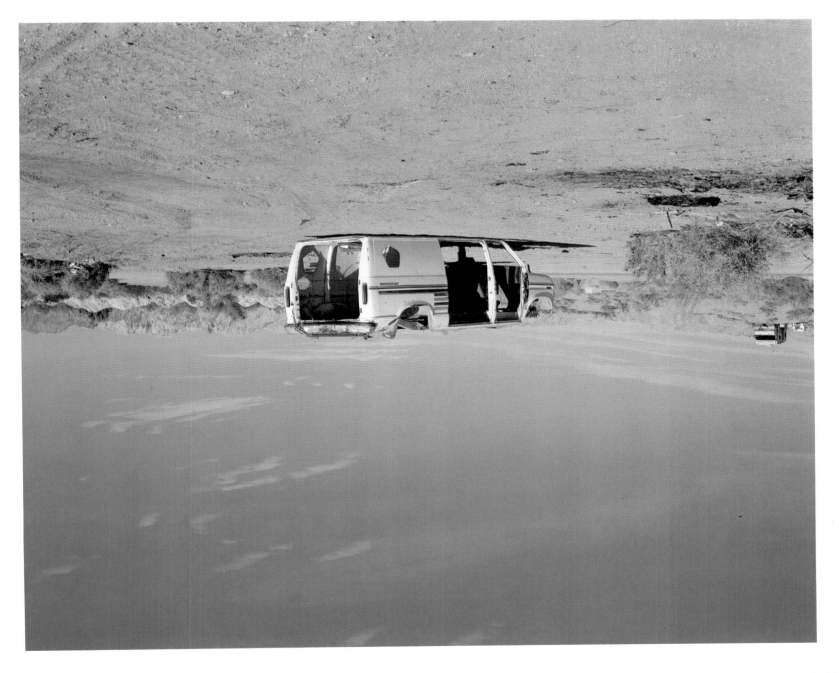

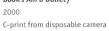

below, **soma**
1999
Digital C-print mounted on
Plexiglas with floating frame
120.5 × 123 cm

opposite, **Untitled (from the
book *I Am a Bullet*)**
2000
C-print from disposable camera

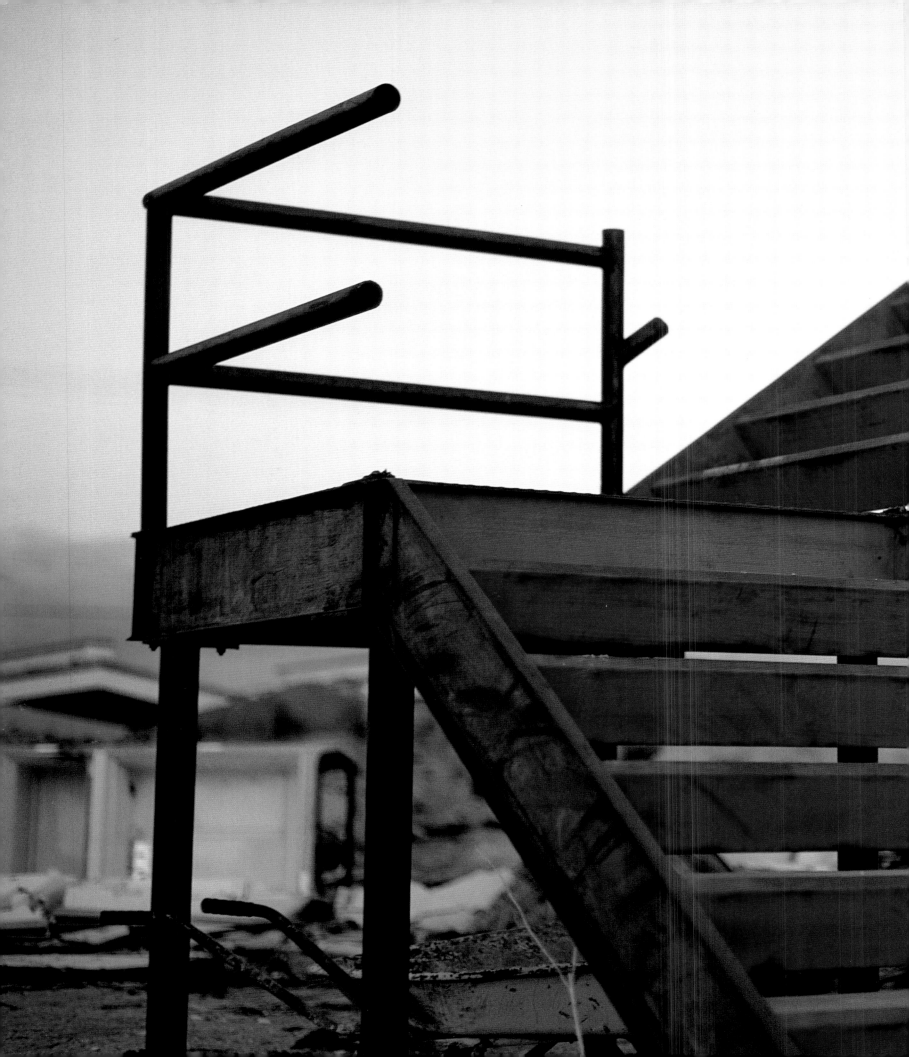

the 4th light
C-print mounted on Plexiglas
2001

opposite, **glass barrier**
2000
C-print mounted on Plexiglas
122 × 157.5 cm

following pages, **new shelter**
2001
Diptych
Digital C-print mounted to
Plexiglas with floating frame.

she answers my questions without hesitation, but now, she stops and thinks for a moment. she slides her coffee around in a small circle on the fake wood table. looking at me, she says, 'you know it's weird. we never stop; we don't have a home. this truck is our home, you know. and still, usually, i only see him for half an hour or so a day.'

'what do you mean?' i ask.

'well, we drive in shifts. one of us is always at the wheel, driving, while the other sleeps. the only time i see him is maybe on the way to use the shower or something. this way we never have to stop. we never need to stop.'

'you like to drive days or nights?' i ask. 'you like to see the country?'
'i like driving at night. i like to see nothing.'
her soft, warm hands pick up the coffee mug and cradle it.
'i like driving at night when there's no one around, when everyone is sleeping. i sit there at the wheel, and i look out, and i don't see the country, the houses, the stores, the markets, the road ... nothing. they're gone, erased, and i'm looking out there, and all i can see is black, pitch black. i mean nothing is out there, nothing at all. and i'm driving, and i'm focusing on infinity, as far as i can see. just nothingness. sometimes if you focus so far, if you look really far, things will come back at you. they'll reflect.
'you know, these mack trucks have a big windscreen. at night it's just black, the whole thing, and it becomes like this big black movie screen. in my mind, i'm projecting my own movies onto it. all these thoughts and memories i have, i watch them on this big, black, moving screen, and it's all just reflecting back on me. i like that; it's why i only drive at night.'

i can see down the hallway toward the coin-operated showers where her husband is finishing up. i watch him grab his towel then look at the clock on the wall. it's time to leave.
Previously unpublished

Artist's Writings